MAGIC?

MAGIC OF COLOR TV AND YOU CAN SEE IT EVERY DAY!

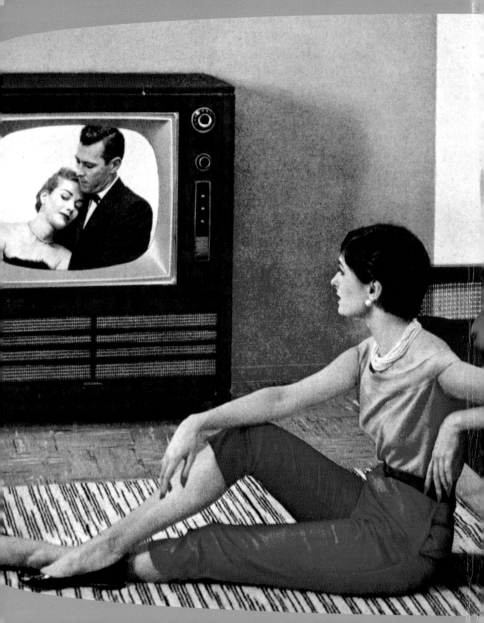

TV

The Enchantment of Early Television

wonderland

by Brad and Debra Schepp

Book Design: Lisa M. Douglass
Project Manager: Jennifer Weaver-Neist
Editor: Jade Chan
Proofreaders: Michelle Erickson and Lisa Perry

Library of Congress Cataloging-in-Publication Data

Schepp, Brad.
 TV wonderland : the enchantment of early television / by Brad & Debra Schepp.-- 1st American ed.
 p. cm.
 ISBN 1-933112-05-0 (pbk. : alk. paper)
 1. Television--Social aspects--United States. 2. Television broadcasting--Social aspects--United States. I. Schepp, Debra. II. Title.
 PN1992.6.S274 2005
 302.23'45'0973--dc22

 2005000507

Printed in Singapore

9 8 7 6 5 4 3 2 1

Collectors Press books are available at special discounts for bulk purchases, premiums, and promotions. Special editions, including personalized inserts or covers, and corporate logos, can be printed in quantity for special purposes. For further information contact: Special Sales, Collectors Press, Inc., P.O. Box 230986, Portland, OR 97281. Toll free: 1-800-423-1848.

For a free catalog write: Collectors Press, Inc., P. O. Box 230986, Portland, OR 97281. Toll free: 1-800-423-1848 or visit our website at: collectorspress.com.

CONTENTS

Introduction

We are members of the first generation to have lived our whole lives with a television set in the living room. Our parents and older siblings may remember flipping through the newspaper or reading a comic book while listening to a radio program, but for us it was that magic box of light from the very beginning. We were born into the wonder of TV and have only heard the stories of its thrilling arrival from those who were there to witness it. But as you page through this book, you'll see just what a thrill it was! To suddenly have pictures and sound come beaming into your home through a box in the living room was astounding enough; to then watch as that box began to offer dramatic presentations, variety programs, sports spectaculars, and then weekly installments of the lives of favorite characters was more than most people could have imagined.

Ultimately, TV became a window to the world outside and a mirror of the people who watched it. Through TV's magic Americans gained entertainment

choices they never could have ever experienced at the movies or the theater alone. Even more importantly, viewers gained an image of American life through both fictional TV "shows" and news productions that made them stop and question who they were and where they were headed. From the Golden Age of Television Drama, they saw some of the finest acting and writing humankind

had ever produced, all from the comfort of home. Beloved situation comedies helped them relax and take a pleasant look at life as they wished it really were. But from that same front-row seat, they watched the House Un-American Activities Committee, the Civil Rights protestors, and the upheaval on campuses during the Vietnam War. Once viewers saw world events — in their own homes and on their own TV screens — the challenges other Americans were facing were no longer someone else's problems.

TV is perhaps the most fascinating of all the distractions humans have made for themselves. At the same time, it is a wonder full of power — the power to make viewers think, the power to make viewers feel, and the power to make viewers look at themselves.

TV arrived on the American scene in the late 1940s, but it was really in the works and ready to go a full twenty years before its official debut. Modern TV

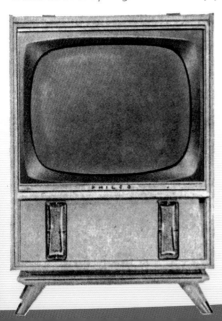

fans owe most of their thanks to a young farm boy from Utah named Philo Taylor Farnsworth, who was born in a log cabin in 1906. Philo spent his early years helping on his father's farm, riding a horse to school, and thinking very seriously about electrons and electricity. By the time he was fourteen years old, he'd developed a plan to scan images electronically so that they could be transmitted in the same way that sound could be sent through the air.

Legend has it that the idea came to him while he was plowing his father's field and noticing the horizontal line patterns emerging row after carefully plowed row. Perhaps images could be built in the same fashion, line by electronic line.

Fortunately for young Philo, he had a high school teacher who recognized his genius, encouraged his studies, and helped him get admitted to Brigham Young University at the age of fifteen. He studied at the university for two years before his father's death left him without the funds to continue. This abrupt ending to his formal schooling did not seem to stop him, and in 1927, at the age of twenty-one, he successfully transferred an image of a straight line etched into a piece of smoked glass from one room of his laboratory to another.

Such an inspirational and fascinating story of a young, poor boy pursuing his dream and bringing the world one of its most amazing inventions seems like the kind of story everyone loves. And yet why do so few modern people know him as the inventor of television? Thomas Edison stands proudly in history next to his lightbulb. Alexander Graham Bell is known for his telephone. Even Eli Whitney still gets credit for the cotton gin no one even uses anymore. What ever happened to fame and fortune for Philo T. Farnsworth?

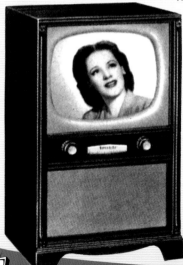

As in any good TV story, there's a twist: While young Philo was struggling in his own little laboratory, Vladimir Zworykin, a Russian immigrant with a PhD in electrical engineering, was working with Westinghouse to create an electronic television system. He wasn't able to do it, but when Philo was

successful in 1927, Zworykin was already working for RCA. He and RCA president David Sarnoff kept young Philo tied up with patent lawyers for nearly two decades. By the time the courts decided that all of Philo's patents were valid, they were almost ready to expire. Farnsworth never received the compensation or recognition he deserved. So young American genius meets huge American corporation, and although justice ultimately prevailed, it came

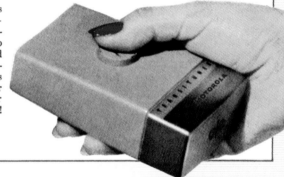

ANOTHER MOTOROLA EXCLUSIVE!
New all-transistor wireless remote control

Change TV channels from your easy chair—without wires or flashing lights! Merely tap new "Transituner" and change channels perfectly—from clear across the room. It's another Motorola transistor miracle. Try it today!

at a high cost to our young hero. By the time he received the patents he was so disillusioned by his experience that he took little pride in his invention.

Of course, Sarnoff and Zworkin went on to be considered pioneers in early television. Sarnoff, in particular, is well-remembered as a founding father of the industry and Farnsworth has gone down in history as a mere footnote.

The birth of TV itself struggled, not only with the wrangling of its parents, but also because of its timing. Although Philo proved the efficacy of TV in 1927,

the first public debut of a television transmitting system would have to wait out the Great Depression before finally appearing at the 1939–40 World's Fair in Flushing Meadows, New York. In tune with the Fair's theme, *"Building the World of Tomorrow,"* there, for the first time, average Americans could take a look at the wonderful machine that made images and sound come alive in a little box right before their eyes. Sadly, this first glimpse would have to be enough for a while. Americans were forced to put away the hopes of more while the world went to war. During World War II, American factories and creative resources were directed to just one thing: victory.

Once the war was over and victory was at hand, Americans were free to return to the good things life had to offer, and TV was waiting to take its place as one of the best things to have ever been invented. In the twentieth century, the world gained automobiles, the power of flight, medical advancements, and the atomic bomb, and made multiple trips to the moon, but many of these achievements were viewed through the great invention of television.

With the war behind them, American factories were retooled to create

peacetime products. For the first time in years, new cars, new washing machines, and new farm equipment took their places on American assembly lines. Making TVs was a perfect way to put the skills of so many radar-trained and radio-savvy veterans back to work. The industry of producing TV programs was set to take off, too.

Americans were eager for the good times, and TV would be there to chronicle those times in all their glory. New products — from hair dryers to dishwashers — and new programs helped Americans believe in the future they saw on their TV screens. Advertisers quickly saw the power of this new medium, and a new age of advertising blossomed to make everyone want first one TV, then more than one, then sets that were fancier, better, and easier to use. Through advertising for TVs and advertising on TV, Americans came to view all the material wonders just waiting in the prosperous world carved out after World War II, when America was truly on top of the world.

TV advertising promised better and less expensive TVs as well as better, happier, more fun-filled times with the family. Each new model introduced would be more luxurious and more ultramodern than the last. TV would quickly grow to offer something for everyone — Mom, Dad, and the kids, too. Americans would gain countless opportunities to gather together with both family and friends to enjoy the magic of programs beamed right into their

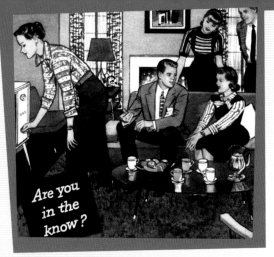

Are you in the know?

homes. Whether they all cuddled together to watch Mary Martin fly through the air as Peter Pan, scheduled their plans to include the annual showing of the classic movie *The Wizard of Oz*, or gathered around their new TV to celebrate the holidays, TV became a member of the family.

In the early days of TV, who could have imagined the place television would take in American life? TV is no longer merely a wonderful occasional distraction; it is an integral part of every day. It informs. It keeps people company when

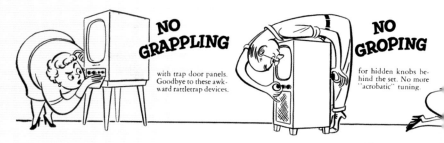

NO GRAPPLING with trap door panels. Goodbye to these awkward rattletrap devices.

NO GROPING for hidden knobs behind the set. No more "acrobatic" tuning.

they're sick or lonely. It has given Americans a cultural identity that makes them recognize themselves and each other every time they turn on the TV. Throughout all the years Americans have loved their TVs, they have still maintained a sense of its wonder.

Today's advertisements, like those of the early years of TV, still promise bigger, more, and better TV viewing. Now that means home theater systems, satellite

TV services, and hundreds of cable stations. It also means linking the home computer to the TV for access to digital content anytime we want it. Today's most coveted TVs are giant plasma and flat-screen works of art that hang on the wall, seemingly magically suspended, and bring the biggest, brightest view of the world possible. But as amazing and futuristic as these images may seem, you'll still find the couple snuggled up on the sofa to enjoy the show, or the dad stretched out across the floor, ready for the game. The kids have their places in this advertising, too, as kids have always had. Today's kids may be much more tech-savvy than the kids who first marveled at TV, but they love it just the same.

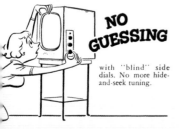

NO GUESSING

with "blind" side dials. No more hide-and-seek tuning.

So settle into that cozy spot on the sofa or on your favorite place on the floor, grab some chips and dip and a bottle of soda pop, and let's stroll back through the 1940s, 1950s, and 1960s. It's a chance to enjoy once again the images Americans created to celebrate, advertise, and spread the wonderful new marvel of television.

New & Improved!

Welcome to the new and improved world of modern television! Almost from the time the very first TV arrived in an American home, television was surrounded by the promise of better technology, better entertainment, and better living. And who deserved this promise more than the generation who had lived through the Great Depression and fought in World War II? At first, it didn't really matter that only a few TV stations broadcasted just a handful of shows for a few hours each week; if your family was one of the lucky ones who could afford to have a television set, you were living a dream come true.

With Dad home from the War, Mom home from her job, and babies arriving faster than ever before in history, the time was right for looking forward, and looking forward included gazing at a new TV screen. The whole family gathered together to watch Milton Berle on *The Texaco Star Theater*, and the neighbors often joined in on the fun, too. It's no wonder that within months, the great Vaudeville star was nationally known as "Uncle Miltie"; he was part of the family. By the early 1950s you could tune in to dramas, situation comedies, variety shows, sports events, movies, and game shows.

The first TV sets were behemoths! Huge cabinets housed tiny 10-inch "peep-show"-sized screens. The family gathered around to stare in wonder at the new marvel, but they all had to sit pretty close to it to get a good view. And variable reception and imprecise controls made tuning in images challenging. Homes located close to the transmitting stations, mostly near large cities, had a better chance of getting good reception. As the distance between transmitter and TV set increased, reception grew spotty and was easily affected by weather and wind. There was little standardization in controls on early TV sets. Some controls were on the top of the set, others appeared across the front, while still others were set in the back of the set. Knobs often controlled more than one function of the set, too. For example the same knob might control volume and brightness, so that it was quite easy to turn up the sound and disturb the picture all at the same time.

By 1950 there were TV broadcasting stations in twenty-five cities across the United States. Market and consumer forecasts called for stations in forty-three cities by the end of that same year. With such rapid growth, TV sets just got better and better. By the early 1950s viewers had lots of choices in models. Screens grew larger and prices came down so that you could buy a TV set with a 21-inch screen for the price of a 17-inch set just a few years before. By the middle of the decade, remote control devices adjusted volume and channels from the comfort of Dad's recliner, which made the awkward chord stretching from the set to the chair a worthwhile price for luxury.

Early TVs were more than just new toys. They were also designed to be an important part of the décor of any room. TVs came in beautiful wood cabinets of every hue and style, from Danish modern to French provincial. Many of these consoles came complete with doors that let you hide the screen when you weren't watching it. The consoles alone made lovely additions to any family's living room, and they made a clear statement of where a family stood on its road to achieving the American Dream.

TV shows originally targeted the whole family, but as TV-viewing became a larger part of everyday life, family members began to gravitate toward their favorite shows. Networks complied by offering shows intended for specific audiences. *The Texaco Star Theater* fell out of favor as stations spread across the country. Berle's fast-paced, slapstick, madcap humor had an urban edge that simply didn't play as well to people in the Midwest as it did with those in the urban centers who had once made up the majority of TV viewers. Howdy Doody took his place as the favorite character of a whole generation of children who spent their afternoons with their favorite puppets while waiting for Mom to fix supper and for Dad to get home from work. Dad could settle in after a long day to an episode of *The Untouchables*, and Mom was almost certain to be watching her favorite soap opera, *Search for Tomorrow*, while she ironed the family's clean laundry. As TV grew and improved it was able to provide something for each member of the family, and programming would only continue to get better.

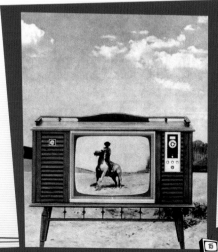

Zenith for '55 brings you the revolutionary new **Model X**

with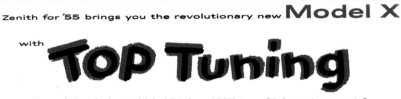

Now you don't even bend over to click the dial. And every "click" brings you TV's sharpest picture automatically

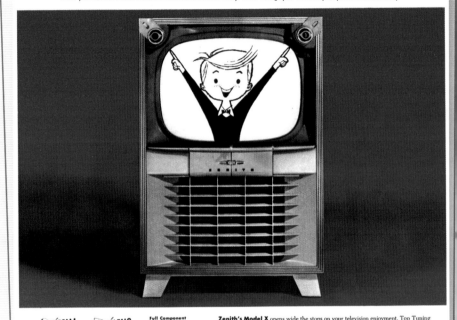

◄ CINÉBEAM

Picture Tube
for nearly twice
the brightness
Inside mirror concen-
trates the power of all
20,000 volts on the
picture.

CINÉLENS

**for television's
sharpest, clearest
picture**
The plus factor for
Cinébeam, screens out
room light, intensifies
contrast, without glare.

**Full Component
HIGH FIDELITY**

Sound system
Zenith - built dual
speakers with 10"
woofer, push-pull am-
plifier add new "you
are there" reality to TV.

Zenith's Model X opens wide the stops on your television enjoyment. Top Tuning
is just the beginning. You get TV's sharpest, clearest picture from every station in
your range. Zenith's own all-new high voltage Royal "R" Chassis has outperformed
other sets tested against it, even in TV's toughest trouble spots.

Zenith's famous one-knob Turret Tuner does the tuning for you on VHF (or
UHF by the simple addition of UHF tuning strips or Zenith's All-Channel UHF
Continuous Tuner†). The sound comes through on Zenith's own Full Component
High Fidelity Sound System, and adds a totally new dimension to your TV expe-
rience. $379.95* in Mahogany. As shown in Blonde, $389.95*, at your Zenith dealer's.
†Optional in UHF areas at slight extra cost.

Zenith TV for '55 starts as low as $159.95*

The Melbourne, Model R1812R, 17" Ciné-
beam television with Ciné-Lens, built-in
antenna, Spotlite Dial, $179.95*

The Sutton, Model R2230R, Full 21" Ciné-
beam television with Ciné-Lens, built-in
antenna, 5¼" Alnico speaker, $219.95*

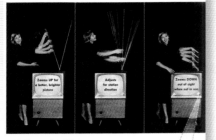

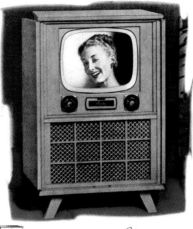

Television is coming. And every step in its development is news," began a Scripps Howard (newspapers) ad from 1929. Although it would be years before many people owned their own sets, television was exciting news even then.

Now! No more tuning...
New Westinghouse TV does it for you!

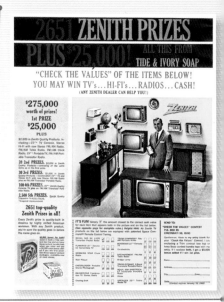

Television's coming-out party was held at the 1939 New York World's Fair. Only a few hundred people owned TVs at the time. Their cost? About $600, or the price of a new car.

DRESSES BY CEIL CHAPMAN

...WITH THIS NEW COLOR DISCOVERY YOU'LL LOOK EXQUISITE YET NEVER "MADE UP"...EVEN UNDER THE MOST GLARING LIGHT

Today Max Factor brings you a new concept in make-up, a discovery that makes possible new subtle colors that give you a look of radiant natural beauty all other make-ups have strived for without success. He calls this great new make-up Hi-Fi.

Hi-Fi does for skin color tones what high fidelity does for sound. Hi-Fi achieves delicate gradations of color never before possible. It makes your natural skin tone come vibrantly alive.

You'll love the look of it . . . true natural beauty . . . softened, heightened, flattered to exquisite perfection.

You'll like the feel of it . . . its new lighter texture, the way it smooths on . . . the way it softens your skin.

This new idea in color for make-up was developed to fill an urgent need created by color television. Existing colors in make-ups appeared harsh, unflattering, unnatural. So the great TV studios called in Max Factor because of his tremendous experience in color research for make-up.

And Max Factor created for their exclusive use, the new concept in make-up colors that was needed . . . a concept which faithfully reproduced natural skin tones

that stay smooth and radiant under the most glaring light.

Now—he translates this amazing high fidelity color principle into a new fluid make-up *made for you*. Hi-Fi! Today you can walk into a store and select your own shade in Hi-Fi Fluid Make-up. The only make-up that makes you look as if you had the most wonderful natural color . . . with never a "made up" look! Six highly flattering high fidelity skin tones.

Hi-Fi Fluid Make-Up by Max Factor **$1.75** plus tax.
New high fidelity colors in Fluid Rouge **$1.25** plus tax.

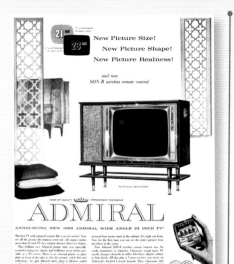

In 1947 commercial TV got its real start with a whopping sixteen stations. There would be more than one hundred stations by the end of the decade.

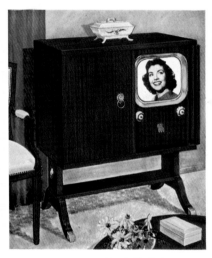

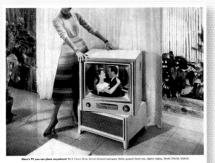

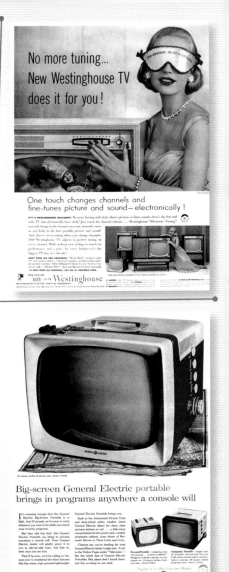
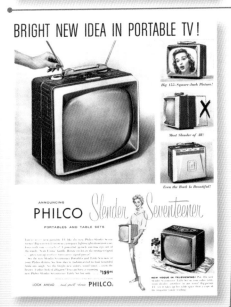

PHILCO ANNOUNCES A
OF HIGH FIDELITY

PHILCO

HF-200 Golden Grid

TELEVISION

World's First High Fidelity Television With Deep Dimension Picture!

IN performance and picture quality, here—from the laboratories of Philco—is television perfected beyond anything known to the TV world.

No other receiver ever built so completely overcomes the obstacles of distance, interference and noise, or so completely solves the problems of picture stability, contrast and definition. It has no equal in distant or difficult areas. Everywhere it adds *new miles* to reception, new quality of *depth* to the picture. Now you see, not just part of the picture, with background detail lost in blur and diffusion, but *all* of the picture in *deep dimension*.

Philco HF-200 television is available in a whole series of striking new models in 27, 24, 21, and 17-inch screen sizes . . . luxurious combinations, consoles, and table models in the widest range of fine cabinetry ever offered. Your Philco dealer has them on display with all of Philco's new 1954 television, including famous Golden Grid models — first in public demand all over America — now offered at new low prices for 1954.

ADDS NEW **MILES** TO TV RECEPTION

ADDS NEW DEEP DIMENSION TO THE PICTURE

Every Philco is available with Philco's exclusive built-in All-Channel Tuner for UHF.

See your nearest Philco dealer now. 1954 Philco prices range from $179.95 to $1,000, including federal tax and warranty. Specifications subject to change.

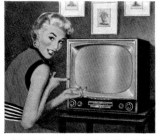

PHILCO 4004, spectacular value in 21-inch table model with Philco's exclusive directional all-channel electronic built-in aerial. Handsome mahogany finish cabinet of original design. Smart matching mahogany finish table also available.

FAMOUS GOLDEN GRID television at new low prices for '54. This 21-inch blond oak console — the Philco 4306-L—is just one of many new and beautiful Philco consoles at your dealer's now.

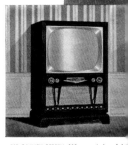

BIG 24-INCH SCREEN, 335 square inches of the finest picture in television . . . in no more room space than many 21-inch sets. Mahogany veneer cabinet on swivel casters. Philco 6106.

NEW WORLD STANDARD
TELEVISION

PHILCO 4308, 21-INCH CONSOLE

PHILCO.

Philco Factory Supervised Service, industry's largest organization of factory-trained TV specialists . . . available through your dealer. Philco Replacement Tubes improve the performance of any television or radio receiver. ® PHILCO CORP

THE 4308 21-inch console (open view). Imported English hardware. African mahogany veneers, deeply recessed doors typify its luxury. Television at its finest . . . in performance . . . in beauty.

BRAND NEW

(makes yesterday's TV old-fashioned)

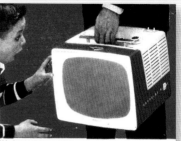

14-inch over-all diagonal (108 square inches of viewable picture area). Two models, in choice of 2-tone color combinations. Shown: Model 14S206.

17-inch over-all diagonal (154 square inches of viewable picture area). One of two big-screen Hotpoint Portables for '58. Shown: Model 17S305.

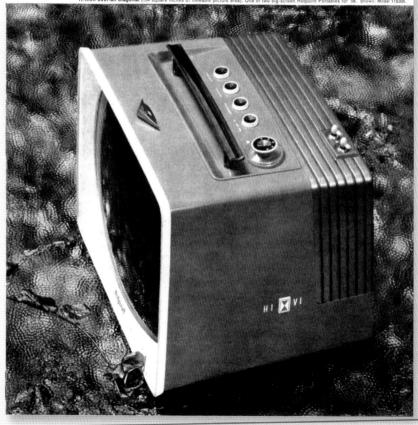

HI VI

Advances in technology and RCA's introduction of the 630TS RCA Victor television set in 1946, which cost $375, helped jump-start the TV industry.

By 1949 Americans were buying 100,000 TV sets a week.

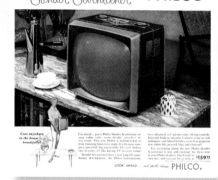
Zenith developed the first wireless remote control, the "Space Command," in 1956. The company is also responsible for "Lazy Bones," the first-ever remote control, which was introduced in 1950. Unlike its 1956 upgrade, it featured a cumbersome cable that spanned between viewer and set to operate a motor on the tuner. (And so the first couch potato was planted!)

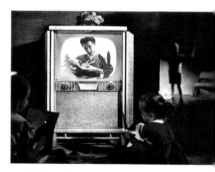
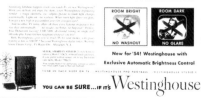

Slim silhouette portable in Turquoise & Mist Green. Model 17P1330, 17-inch (over-all diagonal) tube. 155 sq. in. of viewable area. Other colors: Beige & Tawny White, Charcoal & Mist Gray.

New! 1958 General Electric Big-Screen Portable works wherever a console will—goes where a console won't. Has even greater pulling power than before. The new 110° tube gives it 11 square inches more picture—155 square inches! Yet the cabinet's slimmer (a shelf-deep 15 inches), the whole set's lighter (a trim 30 pounds) than before. Built-in, telescoping antenna. Retractable handle. See your General Electric dealer now.

Progress Is Our Most Important Product

GENERAL ⒼⒺ **ELECTRIC**

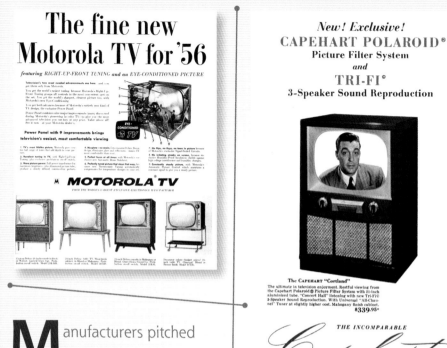

The fine new Motorola TV for '56

featuring RIGHT-UP-FRONT TUNING and an EYE-CONDITIONED PICTURE

Television's two most needed advancements are here - and you get them only from Motorola.

You get the world's easiest tuning, because Motorola's Right-Up-Front Tuning groups all controls in the most convenient spot on the set. You get the world's sharpest, clearest picture too, with Motorola's new Eye-Conditioning.

You get both advances because of Motorola's entirely new kind of TV design, the exclusive Power Panel.

Power Panel combines nine major improvements many discussed during Motorola's pioneering in color TV - to give you the most advanced television you can buy at any price. Value above all, see it now - at your Motorola dealer's.

Power Panel with 9 improvements brings television's easiest, most comfortable viewing

MOTOROLA TV

FROM THE WORLD'S LARGEST EXCLUSIVE ELECTRONICS MANUFACTURER

Manufacturers pitched early TVs as a way to avoid standing in lines to get into sporting events. "See the Races, Ball Games, and the Fights, from the Best Seat in Your House!" read an early ad for the DuMont "Clifton." But its price-tag of $795 would have paid for a lot of ringside seats!

New! Exclusive!
CAPEHART POLAROID®
Picture Filter System
and
TRI-FI°
3-Speaker Sound Reproduction

The CAPEHART "Cortland"
The ultimate in television enjoyment. Restful viewing from the Capehart Polaroid ® Picture Filter System with 21-inch aluminized tube. "Concert Hall" listening with new Tri-Fi° 3-Speaker Sound Reproduction. With Universal "All-Channel" Tuner at slightly higher cost. Mahogany finish cabinet.
$339.95*

THE INCOMPARABLE

Capehart

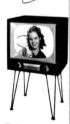

Here is the greatest advance in television viewing - the sensational, built-in Capehart Polaroid® Picture Filter System. No more eye-straining glare. No more eye-fatiguing reflections of lamps and windows. This Capehart picture is the clearest, sharpest, most brilliant you've ever seen - and so "easy-on-the-eyes." Prove it yourself. See a demonstration at your Capehart dealer's today! Your classified directory lists your nearest Capehart dealer.

The CAPEHART "Bedford"
Trim instrument styled of rugged, attractive mahogany Floratone. Capehart Polaroid ® Picture Filter System with 21-inch aluminized tube for "easy-on-the-eyes" viewing. With Universal "All-Channel" Tuner at slightly higher cost. (Wrought iron legs optional.) **$229.95***

*Suggested retail price. Prices slightly higher in the South and West.
® By Polaroid Corporation © Copyright*

You can buy a Capehart television set for as low as $169.95*

CAPEHART-FARNSWORTH COMPANY, Fort Wayne 1, Indiana
A Division of International Telephone and Telegraph Corporation

28

See color television every night on NBC—a service of RCA.

From TV camera to TV set— it's RCA all the way for Big Color

When you sit enthralled at color television, remember that it is brought to you on a full scale by RCA and NBC. The finest programs and television equipment – from camera to home receiver – bear the RCA hallmark of electronic quality and dependability.

Indeed, RCA pioneered and developed the compatible color television system that lets you see color and black-and-white programs on the same receiver. Then an RCA Big Color TV set is actually two sets in one.

Your RCA Victor dealer welcomes the opportunity to demonstrate color television to you. You'll see exciting programs as you've never seen them before – in glorious color that is as faithful you can tell the exact shade of your favorite star's eyes.

Color television is one more achievement in "Electronics for Living," made possible by the work of RCA scientists at the David Sarnoff Research Center, Princeton, N. J. And even now, these scientists continue to explore other electronic frontiers that will make life easier, happier, safer.

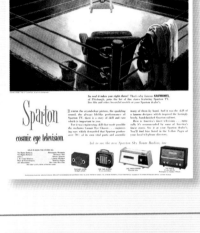

BIG COLOR: The Aldrich by RCA Victor 21" in a versatile picture size, "ColorQuick" tuning, enjoy a child can do it. $495.

RCA RADIO CORPORATION OF AMERICA
Electronics for Living

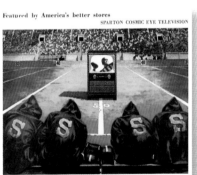

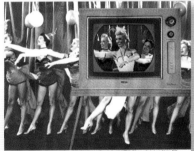

All RCA Victor Big Color TV sets bring you a full 254 square inches of viewable picture. Shown, the Mayland 21 (21CT666). Mahogany or hand and painted finishes. $695.

THE WONDER WORLD OF COLOR IS YOURS WITH RCA VICTOR BIG COLOR TV FROM $695

LIKE HAVING 2 SETS IN 1

You can get both color programs and black-and-white shows on every RCA Victor Big Color TV set! This is Compatible Color, pioneered and developed by RCA.

RCA VICTOR

FIRST IN BLACK-AND-WHITE TELEVISION • FIRST IN COMPATIBLE COLOR TELEVISION

NEWEST GENERAL ELECTRIC PORTABLE TV...

Takes you out to the ball game. Indoors—outdoors or travellin', there's no longer any reason for missing your favorite TV programs. Make this newest G-E Portable TV a vacation "must." New Fold-Away Antenna available for added convenience.

Happy way to keep peace in the family. Stop arguments over which TV program to see. Stop grumbling because you're always missing out on your favorites. The happy solution is a new G-E Portable that you can plug in anywhere for all 'round the house TV fun.

Just what the doctor ordered. What a blessing this new Big-Screen Lightweight G-E Portable is to "shut-ins." "Nothing like it for cheering up patients" say nurses. And what a welcome, inexpensive addition to doctors' waiting rooms, to rumpus rooms, business offices—on any campus.

56% BIGGER PICTURE

GENE...

Progress Is Our Most Important Product

GENERAL ⓖⓔ ELECTRIC

31

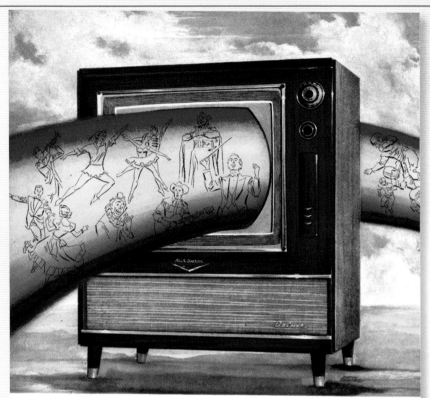

The Director 21. Model 21CT662. In Mahogany finish or blond tropical hardwood. $89

After years of experience and research—

RCA GIVES YOU THE RAINBOW—ENJOY IT!

It's here—*big color television*, as pioneered and developed by RCA.

It's here because as far back as 1920, RCA started the first experiments with TV. Now, 35 years later, color TV is ready for you. You can enjoy the thrill of true-to-life, big-as-life 21-inch color TV in your own home, at reasonable cost. And the colors are unbelievably natural ... vivid ... *sharp*. Here is TV's final touch of beauty!

As families cluster around their 21-inch RCA Victor Color TV sets, they can enjoy the finest entertainment from the National Broadcasting Company — a service of RCA. They can see an ever-growing number of color programs, such as this year's World Series. Ahead lie brilliant "Spectaculars." More NCAA college football. The new series, "Maurice Evans Presents," brings to the color screen the plays of master dramatists like Shakespeare and Shaw. And even "Howdy Doody" blossoms out in full color five days a week!

This is why we say, "RCA gives you a rainbow of excitement—enjoy it!"

RADIO CORPORATION OF AMERICA

ELECTRONICS FOR LIVING

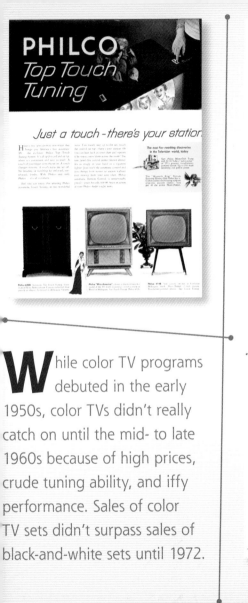
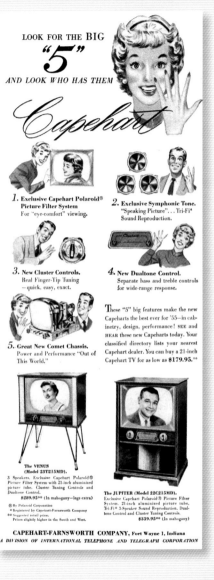
While color TV programs debuted in the early 1950s, color TVs didn't really catch on until the mid- to late 1960s because of high prices, crude tuning ability, and iffy performance. Sales of color TV sets didn't surpass sales of black-and-white sets until 1972.

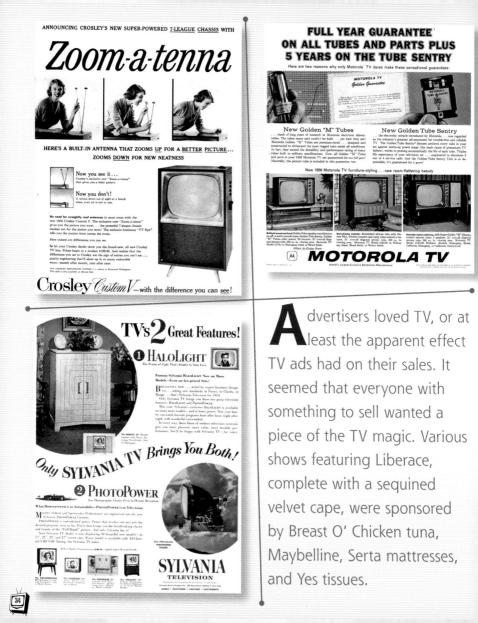

Advertisers loved TV, or at least the apparent effect TV ads had on their sales. It seemed that everyone with something to sell wanted a piece of the TV magic. Various shows featuring Liberace, complete with a sequined velvet cape, were sponsored by Breast O' Chicken tuna, Maybelline, Serta mattresses, and Yes tissues.

One tap...

To change channels, just tap Motorola's Station Selector button.

Channel changes

Click...

Instantly, Motorola TV blanks out picture and sound, and quick as a click . . .

Next channel

. . . your next channel is there, picture and sound perfectly tuned!

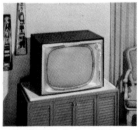

TRANSITIONAL—The clean straight lines and soft gold accents of this Motorola Self-Tuning table model blend perfectly into any decor. Available in Sienna Mahogany or Blond Oak grain finish, with a wide choice of matching bases, it offers outstanding performance at low cost. Model A21T35

Powerful Crosley "7-league chassis" brings the studio right into your home
Only Crosley Custom V has this powerful receiver that reaches out . . . city or country . . . for the station you want.

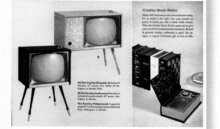

Crosley Book Radio
Made with transistors and sub-miniature tubes, it's so small it fits into your pocket or purse. It looks just like a book when closed. Then the Crosley Book Radio opens up to give you a world of wonderful entertainment. Bound in genuine leather, embossed in gold. Be design, A superb Christmas gift at low as $59.

(A) The Crosley Universal. All Custom V features 21" screen. Your choice of mahogany or blonde finish.

(B) The Crosley Larkwood. Handsome horizontal console model 21" screen. Mahogany or blonde.

The Crosley Ridgewood. Exquisite page 237-vertical console model with walnut tone. Mahogany or blonde.

Crosley *Custom V*
...WITH THE DIFFERENCE YOU CAN SEE!

See it Better *Hear it Better*

STROMBERG-CARLSON
TELEVISION

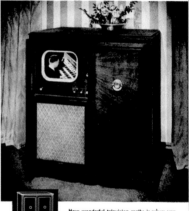

How wonderful television really is when you enjoy it across the room from your big-screen Stromberg-Carlson! When the brilliantly clear and spacious picture you *see* is matched by the famous Stromberg-Carlson tonal fidelity you *hear!* The new Lanchester delights your senses with a big 72 square inch direct-view picture . . . static-free FM, standard broadcast and short wave radio . . . and a *single tone-arm* automatic changer for both long-playing and conventional records. Smart decorator-designed cabinet, in hand-rubbed mahogany veneers. **$879.50**

Plus installation and $7.50 excise tax. Slightly higher in South and West.

Console and table television from $395 to $940
Radio and radio-phonographs from $29.95 to $495

There is Nothing Finer than a
STROMBERG-CARLSON
© 1949, Stromberg-Carlson Company, Rochester 3, N. Y. — In Canada, Stromberg-Carlson Co., Ltd., Toronto

In the late 1940s television was only available in a very few cities, including New York, Philadelphia, Chicago, and Los Angeles. In these "television cities," movie attendance dropped 20–40 percent, ratings for radio shows dropped sharply (Bob Hope's radio rating fell from 23.8 in 1949 to 12.7 in 1951), restaurants and nightclubs saw a big drop in business, and attendance at sporting events also dropped.

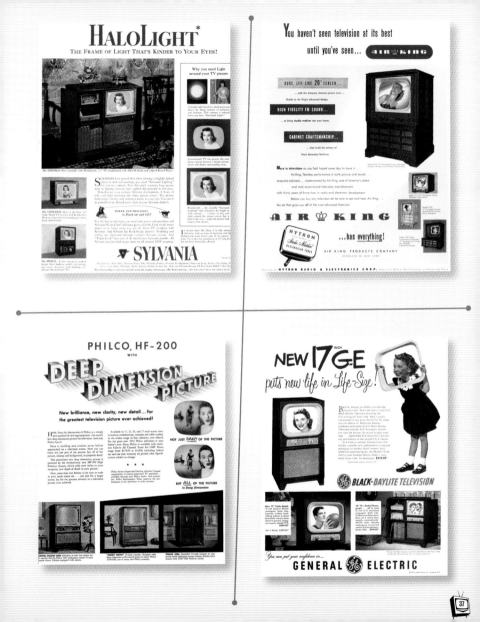

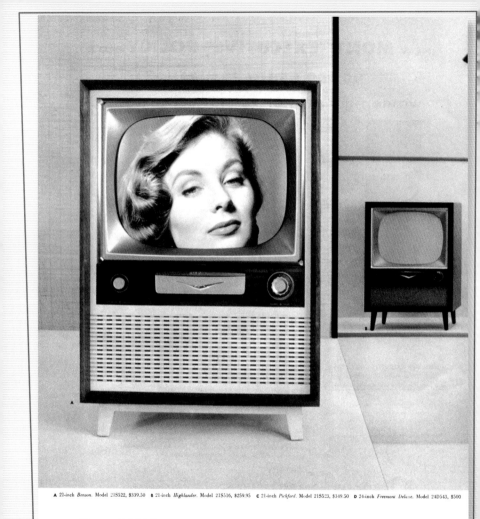

A 21-inch *Benson*. Model 21S522, $339.50 B 21-inch *Highlander*. Model 21S516, $259.95 C 21-inch *Pickford*. Model 21S523, $349.50 D 24-inch *Freemont Deluxe*. Model 24D543, $500

Now—RCA Victor TV as low as $199⁹⁵ with the
NEW <u>OVERSIZE</u> PICTURE!

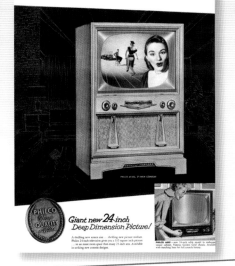

From **PHILCO**

Giant new 24-inch Deep Dimension Picture!

A thrilling new screen size...thrilling new picture realism. Philco 24-inch television gives you a 315 square-inch picture — in no room more space than many 21-inch sets. Available in striking new console designs.

PHILCO 6163L 21-INCH CONSOLE

PHILCO QUALITY MADE

PHILCO 4242 — new 21-inch table model in mahogany veneer cabinet. Famous Golden Grid chassis. Available with matching base for full console beauty.

As TV picture screens grew larger in the 1950s, the cabinets encasing them grew smaller. In the late 1940s General Electric's 10-inch screen offered "a new kind of realism." By the mid-1950s, sets with 21-inch screens were widely available. Ironically, within just another few years, portable TV sets with screens comparable to the earliest models made it possible to take your TV from one room to another.

39

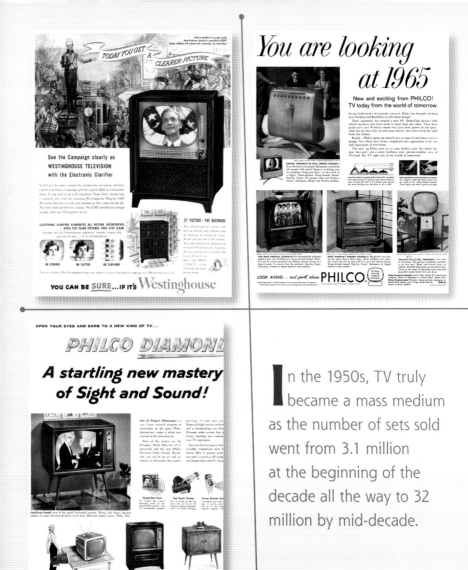

In the 1950s, TV truly became a mass medium as the number of sets sold went from 3.1 million at the beginning of the decade all the way to 32 million by mid-decade.

the BIG *difference*

in **TV** sets

is the exclusive
CAPEHART POLAROID®
Picture Filter System

JUST SEE the difference exclusive Capehart Polaroid® Picture Filter System makes . . . no eye-straining glare, no eye-fatiguing reflections. A Capehart picture is always brilliantly clear and sharp, yet easy on the eyes. If you want the BIG DIFFERENCE in TV sets — the "easy-on-the-eyes" picture — buy a Capehart. Your classified directory lists your nearest Capehart dealer.

21-inch Capehart television instruments from $169.95 to $1600.00*.

®By Polaroid Corporation
* Prices slightly higher in the South and West.

The AMHERST (Model 3T216MD). Capehart Polaroid® Picture Filter System. Super Comet Chassis with 21-inch aluminized tube. Front mounted speaker.

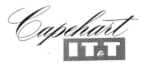

Capehart
IT&T

CAPEHART-FARNSWORTH COMPANY, Fort Wayne 1, Indiana
A DIVISION OF INTERNATIONAL TELEPHONE AND TELEGRAPH CORPORATION

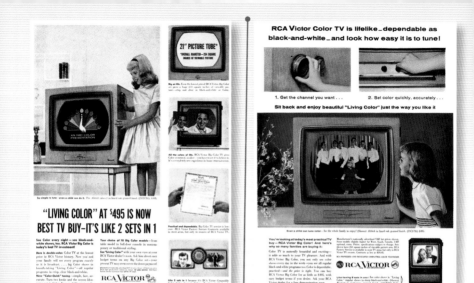

Among all the TV-related technologies and inventions, TV Land, a modern network that replays classic television programs, rates the remote control as the most significant.

W e take our instant-on televisions for granted now, but TV fans of the 1950s had a lot of fiddling to do while they watched TV. Viewing challenges included streaks, flutters, washed-out images, and glare.

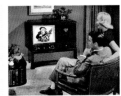

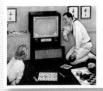

Now see the difference Color TV makes

With the Big Advance in RCA Victor's new Mark Series, the difference is more delightful than ever. Tuning is sure and simple. You can even tune some models from your easychair—get sharp, steady pictures in *natural* color just by pressing a button! **And now another RCA Victor Color TV first!** A free 1-year warranty* on all parts and tubes (including picture tube) with purchase of performance-proved RCA Victor Color TV! The Big Advance is the Color TV news you've been waiting for. See for yourself, *now!* Coming up on NBC-TV alone: the World Series, college football, big color shows every night of the week. At any RCA Victor dealer's. Prices from $495.
*excluding labor

RCA VICTOR RADIO CORPORATION OF AMERICA

SYMBOL OF RCA VICTOR COMPATIBLE COLOR TV

ANDERSON
Striking console in superb new Mark Series

The war years saw TV production and development greatly scaled back as resources were dedicated to the war effort. But after the war, pent-up demand and a thriving economy quickly put TV development back on track.

Most early TV shows had only one sponsor: Pabst Blue Ribbon Bouts, Camel Newsreel, and the Chesterfield Supper Club were among the first of many. These sponsors called all the shots, and influenced story lines and even hiring decisions.

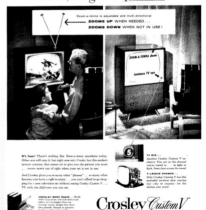

So you told your mother-in-law you're not getting color tv until somebody comes up with a really lifelike color picture?

Better get a new story.

Or a new Philco.

off cabinet depth for a new <u>Slim Silhouette</u>

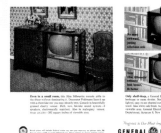

I n 1949 General Electric's (GE) "Daylight Television" — the kind of television "you can enjoy in broad daylight," — boasted a picture tube with greater vividness and clarity than ever before.

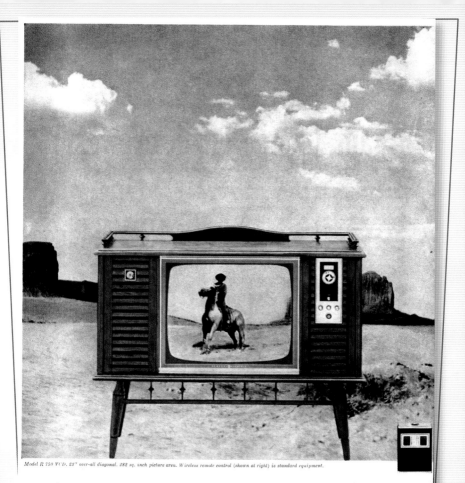

Model R 750 VCD, 23" over-all diagonal, 282 sq. inch picture area. Wireless remote control (shown at right) is standard equipment.

Feast your eyes on the first and only picture as sharp and clear as a Western sky

General Electric

DAYLIGHT BLUE TELEVISION

Let your own eyes convince you that *here is the clearest, the truest picture ever brought to a television screen.*

What's the secret? For the same reason women use washday bluing to brighten whites in laundry, General Electric engineers added an almost invisible blue tint to the picture tube, to whiten whites and sharpen contrast. And here's the best news of all: Daylight Blue pictures are on every General Electric TV set, from the least ex-

pensive portable to the noblest console. A[nd] how trustworthy can a TV set get? A stu[dy] of TV sets over a 3-year period has prov[ed] that General Electric TV needed less servi[ce] than any other leading brand. *See Gene[ral] Electric TV at your dealer: the proof is [in] the picture.*

Progress Is Our Most Important Product

GENERAL 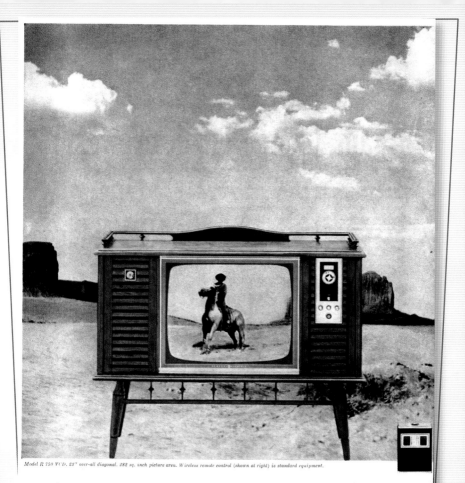 **ELECTRI[C]**

TELEVISION RECEIVER DEPARTMENT, SYRACUSE, NEW YO[RK]

Luxurious & Ultramodern

In the 1950s TV really became part of everyday life for most Americans. In the 1949–50 viewing season, only 9 percent of U.S. households had TVs, but by the 1959–60 season, 87 percent of homes were equipped with these marvels. With *I Love Lucy*, *The $64,000 Question*, and *The Ed Sullivan Show* on the air, TV, not baseball, was the national pastime.

Once most of us achieved the dream of owning our own TV sets, that dream began to expand to include even more luxurious and modern offerings. When everyone had a TV, wasn't it more fun if your TV was a luxury model with features previously impossible to imagine? Happily, the technology kept pace with our desires for more, fancier, and better TVs.

Throughout the 1950s, advancements and enhancements made TVs easier to use, screens easier to see, and TVs themselves even more fun and exciting to have. In 1950 Motorola introduced a TV that had "only two controls": one turned the TV on and off and adjusted the sound; the other was for changing channels. How much simpler could using your TV be?

Comfort was improving right along with easy handling. Philco introduced a TV set with a swivel screen to achieve the best viewing angle from any part of the room. By 1953 Westinghouse marketed a TV set with an automatic picture adjustment feature that included an "electronic eye." This clever little sensor automatically adjusted the contrast on your TV screen in response to the light levels in the room. Now you didn't even have to move a muscle to eliminate that irritating glare on the screen. Indoor antennae, also known as rabbit ears, came with simpler controls to make tuning your picture easier. Some TVs even included an earphone jack so you could rock the baby to sleep without having to miss a moment of your favorite show.

TVs still came in beautiful wood cabinets in the 1950s, but those cabinets often included stereo radios and phonographs. With these wonderful innovations, the family had a complete home entertainment center in one attractive package.

A vancing technology bore smaller and more compact TVs. Manufacturers began to advertise these as "portable" TVs, although at thirty pounds or so, most families found

a place for them and left them there. By 1960 Sony introduced a TV that could fit in your hand! It weighed a mere eight pounds and was "so light you can carry it with you like a book." By 1962 this little marvel cost a hefty $299.99, and that didn't include the battery pack. Still, what a showstopper to appear at the company picnic with your own personal TV!

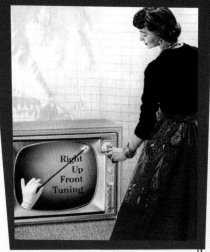

Most consumers didn't go for the miniature TVs, but they did scoop up smaller TVs in new, colorful, plastic cases that gave them a modern, snappy, fun appeal. These new models often supplemented the family's main TV set. Now that nearly everyone had a TV, it became very popular to have more than one. That pink one would be perfect for Susie's room. Or how about that sunny yellow one for the corner of the kitchen?

It wasn't just the TV cases that got splashed with bright and vibrant color. The Federal Communications Commission (FCC) established standards for color TV as early as 1950, when it declared CBS's color technology the industry's norm. But the Korean War delayed the development of color TV the same way World War II delayed TV itself. The first coast-to-coast color broadcast occurred on January 1, 1954, when NBC broadcast the Tournament of Roses Parade through a network of twenty-one stations. This was the largest audience yet — estimated by the *New York Times* at "several thousand" — to view a color broadcast. Industry employees experienced the event on about two hundred RCA Victor prototype color sets. The first color TV went on sale soon thereafter with a set from Westinghouse that cost $1,295. It wasn't until 1966 that NBC became the first network to switch over to 100 percent color broadcasting. It took another six years until sales of color TVs began to outpace sales of black-and-white units.

As much as Americans loved the idea of color television, we waited patiently for technology to bring the cost down. For nearly two decades the answer to the question, "Daddy, can we have a color TV?" was, "Soon." By the time those babies of the 1950s were in college, color TV had long replaced black-and-white as the most popular new TV purchase.

HAT BY LILLY DACHÉ. "COMPATIBLE RED" LIPSTICK BY COTY.

See the difference Color TV makes

You'll see the bright, bold colors at once, naturally. But, here, you can also see the *subtle* beauties of Color TV . . . soft flesh tones, pinks, violets, blues—a whole bouquet of delicate pastels, reproduced so faithfully you want to reach out and touch the screen. You'll see that RCA Victor "Living Color" TV is right and ready for you.

You can prove it to yourself any day of the week. See how exciting and *real* your favorite shows become in color—the great "TV Specials," Dinah, Como, Gobel and many more. Let your RCA Victor dealer show you the easy tuning and proved-performance, now enjoyed in homes all over America. Prices start at $495. *Now!*

Manufacturer's nationally advertised VHF list price shown, subject to change. Some sets slightly higher for West, South. UHF optional, extra.

RCA VICTOR FACTORY SERVICE CONTRACT. Only RCA Victor TV owners can buy an RCA Victor Factory Service Contract for expert service and installation by RCA's own technicians. Branches in most TV areas.

RCA PIONEERED AND DEVELOPED COMPATIBLE COLOR TELEVISION

THE PRIDE OF OWNERSHIP IS SECOND ONLY TO THE PLEASURE

ANDERSON
in the superb new
Mark Series. Striking
Compatible Color TV console

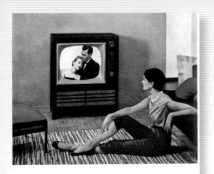

Announcing great new RCA

Television first appeared in the Sears Roebuck catalog in 1949. The bare-bones but sturdy model sold for $149.95 and came with its own "indoor antennae" (rabbit ears).

Contemporary beauty. Swivel base. 23,000 volts of picture power. 27" over-all diagonal measure screen (282 sq. in. viewing area). Model 23K32.

The smart new look of TV reliability

The people who live in this house are obviously partial to ultra-modern things. They also must set great store by reliability, because they depend on the sun tides to fill their swimming pool.

It isn't surprising, then, that they have Motorola's TV in their living room, because Motorola reliability has become the standard by which knowing people judge television sets. There is no reason to settle for anything less than reliability that is backed by Motorola's famous guarantee—in writing—of every tube and part for a full year.*

The chief scientific reason for this is Motorola's exclusive Golden Tube Sentry* unit, which eliminates the warm-up power surge that cuts down the tube life of TV receivers without this patented feature.

You can look forward to clear, crisp reception long after many of your non-Motorola friends are thinking of trading in their sets.

You get this reliability in a wide choice of furniture styles, modern or traditional, including cabinets by Drexel. See Motorola before you select your next television set.

MOTOROLA Ⓜ

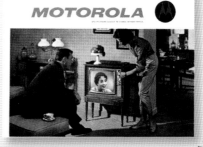

During television's early days after the broadcast day was over, the only thing on TV was a "test pattern." This pattern, drawn on a piece of cardboard, was used to test camera response. The camera focused on this pattern until the regular broadcast day began.

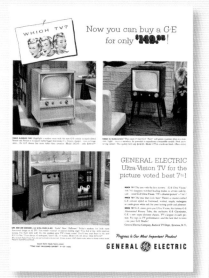

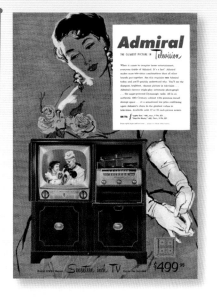

M ore of a "thing of beauty" in the 1950s, many televisions looked a lot more like furniture than appliances. The workmanship that went into TV consoles meant that no one had to worry about basing a room's décor around the new TV.

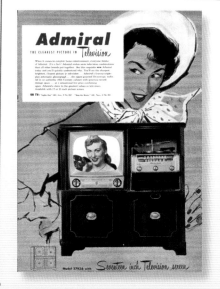

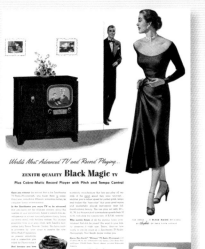
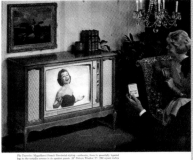

RCA Victor announces the

WITH THE NEW "UN-MECHANICAL LOOK"

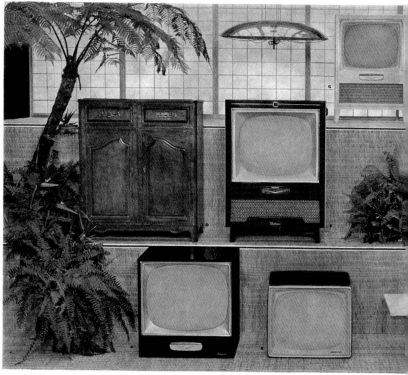

A. 24-in. *Wayland* (24T61 (2) $249.95. B. 21-in. *Headliner* (21T6082) $199.95. C. 17-in. *Thrifton* (17S6022) $149.95. D. 24-in. *Winthrop Deluxe* (24D679) $500. E. 24-in. *Everest Deluxe* (24D655) $349.50.

More—far more—for your money
at every price level—$149⁹⁵ to $500

Walk into any RCA Victor dealer's. You notice an air of excitement.
The Big Change in television has arrived!

Everywhere the "Un-Mechanical Look" catches your eye. This TV
is fine furniture—not mere equipment. In sleek table models like the
17-inch *Thriftton* at $149.95 and the Oversize 21-inch *Headliner* at
$199.95, you see nothing but a fine picture and a luxurious cabinet.

Now you move on to wonderfully low-cost 2-speaker swivel sets—
"Big-Wheel" rollarounds—luxurious "low-boys." Imagine the Provin-
cial 24-inch *Winthrop Deluxe* in your living room! Or the exotic

Big Change in Television

TV'S FIRST COMPLETE RE-STYLING

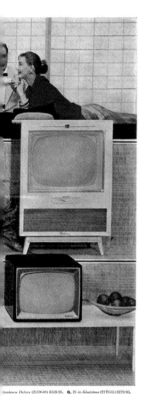

Rittenhouse Deluxe (21D648) $339.95. **G.** 21-in. *Gladstone* (21TG35) $279.95.

...ase *Rittenhouse Deluxe* with its cabinet of *two prized woods*!
...ry RCA Victor set, you see Big Changes in styling . . . and
...nges in performance, too! New "High-and-Easy" Tuning that
... dial standing up—Balanced Fidelity Sound—*$500 picture*
...n sets as low as $200.

...of all, prices are unbelievably low for RCA Victor quality!
...efore have you been able to pick from such a wide range of
...finishes and prices. For the happiest shopping of your life,
...date to see your RCA Victor dealer *soon!*

SEE THESE 7 MAJOR ADVANCES IN STYLING, PERFORMANCE AND VALUE!

1 New **"High-and-Easy" Tuning**—in 3 convenient types! Dial *standing up* . . watch the picture as you dial. (Left) "Hidden Panel" Tuning on most table models. (Right) "High-Side" Tuning for consoles. "Up-Front" Tuning on full-door sets.

2 New **"4-Plus" Picture Performance!** Only RCA Victor gives you all four "plus" factors for TV's finest picture in sets as low as $200:

(1) 100% automatic gain control for constant signal regulation.

(2) "Sync" stabilizer that kills interference jitters.

(3) 7% extra brightness.

(4) 33% extra contrast.

3 New **"Front Window" Channel Indicator!** king-size channel numbers illuminated in window near screen.

4 New **Balanced Fidelity Sound!** Re-creates the *entire range of sound* sent out by the television networks.

5 Eight New **Swivel Models!** New "Big-Wheel" rollarounds, too! Here is television that moves and goes places!

6 **Prices down as much as 18%!** And as much as $100 more value per set than in previous comparable models!

7 The **"Un-Mechanical Look"** in many new woods and finishes! This TV is fine furniture, never mere equipment.

Famous RCA Factory Service, assuring you of expert installation and maintenance is available in most TV areas — but only to RCA Victor TV owners. Ask your dealer for details.

Manufacturer's nationally advertised VHF list prices shown, subject to change. Slightly higher in far West and South. UHF optional at extra cost.

See Milton Berle, Martha Raye alternately on NBC-TV, 3 out of every 4 Tuesdays. And don't miss NBC-TV's "Producers' Showcase" in RCA Compatible Color or black-and-white, Monday, Sept. 19.

RCA Victor salutes National Radio and Television Week—"Dedicated to Better Home Entertainment," September 18 to 24.

RCA VICTOR

RADIO CORPORATION OF AMERICA

EVERY YEAR MORE PEOPLE BUY RCA VICTOR THAN ANY OTHER TELEVISION

ALL-NEW 1954 *Admiral*

BRINGS YOU TELEVISION'S FINEST PICTURE

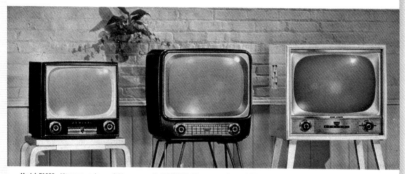

Model T1822—17″ screen—mahogany finish
17″ models start at . . **$159.95***

Model T2222—21″ screen—mahogany finish
21″ models start at . . **$199.95**

Model T2237—21″ blonde oak, legs included
21″ mahogany models start at . . **$269.95***

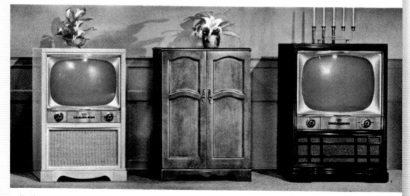

Model C2227—21″ blonde oak console
21″ consoles start at . . **$299.95**

Model F2218—21″ Provincial in maple
21″ half door consoles start at . . **$369.95***

Model C2516—24″ mahogany console
24″ consoles start at . . **$399.95**

RCAs "personal portable," a red metal set with gold trim, featured an all-important handle, which, despite a TV's weight (up to thirty pounds), gave the illusion of portability.

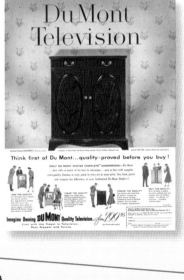

Although screen sizes got bigger, prices stayed the same. A 21-inch "Admiral" sold for $199.95 in 1952.

My second most prized possession

No, Color TV is not Lilly Daché's most prized possession. That exquisite Napoleon chair piece is.

And we won't argue with designer Daché's choice. Especially since she placed Color TV second on her "most prized" list. You probably know some of the reasons for that selection already. The wonderful definition of Color TV makes. The continuing enjoyment it gives. The beauty of the color picture. The pride in owning the finest.

(An interesting sidelight: When she first declined on RCA Victor's demonstration, Miss Daché chose the least expensive of RCA Victor's dozens or so models—the $495 one. Just a matter of personal taste. And no one who has admired a Daché hat could question Lilly's taste.)

In short, one can put Color TV in this "Living Color" TV is the best television there is. That's why RCA Victor Color TV appeals to more and more people like Miss Daché. People who lead the colorful life.

RCA Victor offers Color TV sets at prices from $495. If you are considering one as a second (or third) most prized possession of your own, ask your RCA Victor dealer to arrange a demonstration. See the difference Color TV makes—for yourself.

RCA VICTOR

Westinghouse's 1954 21-inch "Sulgrave" TV came with a new "electronic eye" that automatically adjusted the controls to suit the viewing conditions. Viewers could "sit back and enjoy the show," instead of popping up and down to fix the picture.

NEW ELECTRONIC EYE ADJUSTS PICTURE
FOR YOUR EYE COMFORT... AUTOMATICALLY

Something fabulous happens when you watch TV on new Westinghouse! While you sit back and enjoy the show, a new Westinghouse engineering wonder—a magic electronic eye—adjusts picture to room light changes automatically. Lights on—no washout. When room light dims—no glare. You get a new high in eye comfort, even for youngest eyes!

And no other TV today offers all these extra features in pictures that stay clear automatically . . . no streaks, no flutter, no flop-over! Thrilling True Dimension viewing! UHF-VHF all-channel tuning on single dial! 100-mile-plus Tuner for best reception wherever you live!

Only Westinghouse gives you so much TV for your money, with prices starting as low as $189.95.* See your Westinghouse dealer today. Westinghouse Electric Corp., TV-Radio Div., Metuchen, N. J.

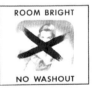
ROOM BRIGHT — NO WASHOUT

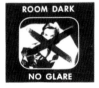
ROOM DARK — NO GLARE

SLEEK, SMARTLY STYLED 21-inch Sulgrave (above). Model 792K21, in blond limed oak finish. If you prefer walnut veneer, ask to see The Granville (left), Model 791K21.

*Price includes Federal Tax and full-year warranty on picture tube. Prices slightly higher in West and Southwest.

New for '54! Westinghouse with
Exclusive Automatic Brightness Control

TUNE IN EACH WEEK ON TV...WESTINGHOUSE PRO FOOTBALL...WESTINGHOUSE STUDIO (

YOU CAN BE SURE...IF IT'S **Westinghouse**

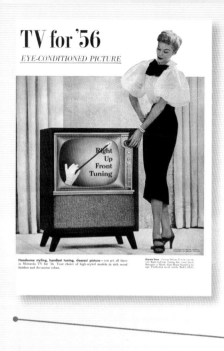

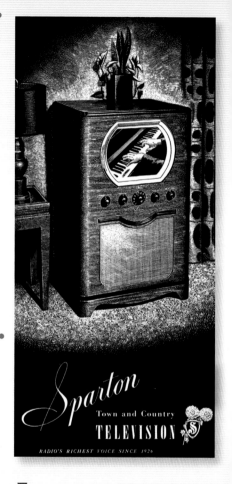

In the late 1940s GE marketed a complete entertainment center that included a TV plus three other "services" (AM and FM radio and a phonograph). The TV had a modest 10-inch screen. Price: $725 plus installation.

In one of the first tests of pay TV in 1958, about five hundred subscribers in Oklahoma paid $9.50 a month for a special movies-only channel.

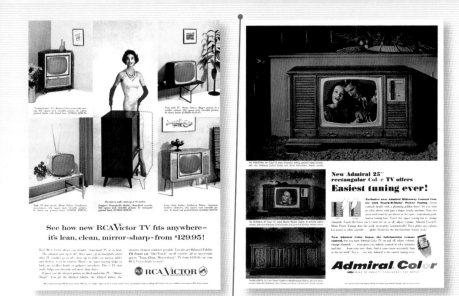

See how new RCA Victor TV fits anywhere– it's lean, clean, mirror-sharp–from $129.95!

New Admiral 25" rectangular Color TV offers Easiest tuning ever!

Admiral Color

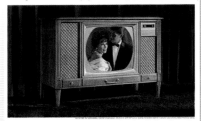

Tilt out....for perfect control of the first really lifelike color in TV history, with exclusive new Admiral Color Fidelity Control and Automatic Degausser – a new color purifier. Instantly, permanently, color's just right!

Tilt in for the beauty look...no knobs show! See the only visible improvements in color TV. **Admiral Color**

When you turn off a Packard Bell color television set, it won't turn you off.

Packard Bell

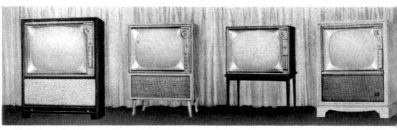

24-inch Deluxe console. Mahogany or Blond woodgrain finish, brass accents. Pushbutton on-off switch. Model 24K10.

Ultra-modern 21-inch Deluxe console. Blond or Mahogany wood with brass-tipped legs. Model 21K39B.

21-inch Deluxe Table Model. Available in handsome Mahogany, Blond or Carnation Pink, Model 21T27M.

21-inch Custom Deluxe. Traditional styling in Mahogany or Blond wood. Pushbutton on-off switch. Model 21K42B.

The fine new Motorola

featuring RIGHT-UP-FRONT TUNING and a

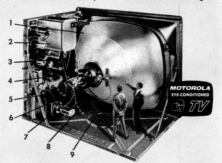

Power Panel with 9 improvements brings television's easiest, most comfortable viewing

(1) **Full range of grey tones** gives Motorola's picture new depth. (2) **Right-Up-Front Tuning**—world's easiest! (3) **Full-Power Transformer** for brighter pictures. (4) **Eye-Conditioning**—world's easiest viewing! (5) **Automatic Beam Stabilizer**, (6) **Signal-Sealed Circuits**, (7) **Thermostatic Tuning**, (8) **Humidity-Proof Insulation**, (9) **Automatic Picture Control**, all work together to give you the clearest, steadiest picture you've ever seen.

Here, in television's most beautiful cabinets, are the two biggest *picture* advancements of the year—and only Motorola has them!

RIGHT-UP-FRONT TUNING gives you the world's easiest tuning, by grouping all controls in the most convenient spot on the set: Right-Up-Front.

EYE-CONDITIONING gives you the world's sharpest, clearest picture, to make long hours of viewing more pleasant and relaxed than ever before.

It took an entirely new kind of TV design—Motorola's exclusive Power Panel—to make these two important advances possible. In the Power Panel, Motorola engineers were able to combine nine major improvements (many coming directly from Motorola's pioneering in color TV).

The result is the most advanced television you can buy today, at any price. See it, *try* it, at your dealer's now!

Handiest tuning, handsomest styling, clearest picture

You get all three in the fine new Motorola TV for '56. Notice how the Right-Up-Front controls are *high*, so you can tune standing up; and *in front*, so you can see what you're tuning. Notice the magnificent cabinetry, too. This year's Motorola TV gives you a choice of many different designs and colors—the most beautiful cabinets in television.

SHOWN AT RIGHT: 21-inch Custom Deluxe home theatre console, in contemporary design with the new "long look." Grey Mahogany solid wood cabinet with built-in magazine shelf, gleaming brass accents. Pushbutton on-off switch. Model 21K45.

M MOTOROLA TV

FROM THE WORLD'S LARGEST EXCLUSIVE ELECTRONICS MANUFACTURER

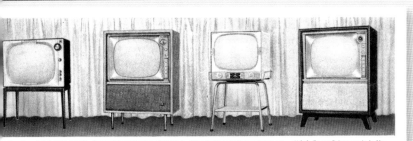

...orator colors—budget price! 21-inch ...e model in a choice of Charcoal, Pink ...lan finish. Model 21T25.

Custom Deluxe 21-inch console in Birch or Walnut, tapered brass legs. Pushbutton on-off switch. Model 21K44B.

Clock TV! Turns itself on or off at any set time. 17-inch, Antique White or Carnation Pink. Table Model 17T26.

21-inch Custom Deluxe console, in Mahogany or Blond wood finish. Pushbutton on-off switch. Model 21K44.

TV for '56

...YE-CONDITIONED PICTURE

Right
Up
Front
Tuning

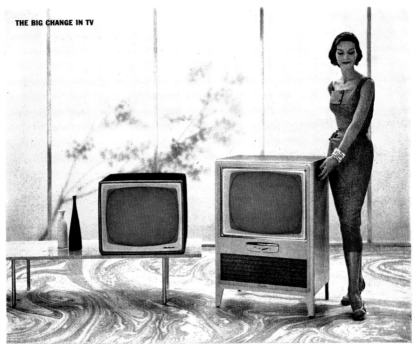

THE BIG CHANGE IN TV

(L) *Headliner 21* (21T6082). Ebony finish, $199.95 Stand, optional, extra. (R) *Gladstone 21* (21T635). Mahogany grained finish, $269.95. Shown, limed oak grained finish, $279.95.

RCA Victor presents TV's <u>first</u> complete re-styling

No obvious dials or gadgets. Nothing in view but TV's finest picture and most luxurious cabinets!

Here is TV that goes far beyond what you've come to expect. *This* TV is more than mere equipment. It breathes style in every line!

Just imagine how you could transform your living room with one of these smart sets. Take the *Headliner 21*. No controls in sight. What a picture it makes—and what a picture you get! Or, for fine performance and a look of richness that belies its price tag, choose the *Gladstone 21* with "High-Side" tuning. Both sets bring you "4-Plus" picture quality—greater brightness, contrast, steadiness.

Great New TV Advances. For as little as $149.95, new RCA Victor TV brings you the fabulous new "Un-Mechanical Look," TV's first complete re-styling...plus new Balanced Fidelity Sound...

plus "High-and-Easy" tuning that lets you dial standing up. *And prices are down as much as 18%.*

More models, more unusual finishes, more beauty, more *sheer value* in TV than ever before —exactly what you want—ready for you now at your RCA Victor dealer's.

RCA Factory Service, assuring expert installation and maintenance, is available in most areas—but only to RCA Victor TV owners. Optional, extra.

Manufacturer's nationally advertised VHF list prices shown, subject to change. Slightly higher in far West and South. UHF optional at RCA Victor's lowest price ever—only $25 extra.

See Milton Berle, Martha Raye on NBC-TV alternately, 2 out of every 3 Tuesdays. And don't miss "Mr. TV," spectacular "Producers' Showcase" in RCA Compatible Color or black-and-white, Dec. 12.

"4-Plus" Picture Quality. Greater brightness, contrast, steadiness. In sets priced as low as $200.

"Hidden Panel" Tuning. Lets you dial easily—standing up.

RCA VICTOR
RADIO CORPORATION OF AMERICA

EVERY YEAR MORE PEOPLE ... CA VICTOR THAN ANY OTHER TELEVISION

64

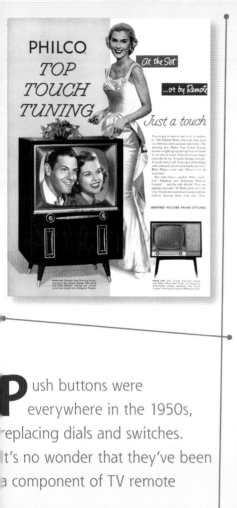

TV screens in the 1950s quickly went from 17 inches to 21 inches (43 percent bigger!), giving Mom and Dad another excuse to trade in the old set.

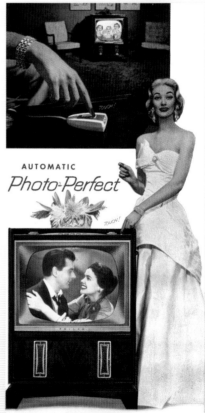

Push buttons were everywhere in the 1950s, replacing dials and switches. It's no wonder that they've been a component of TV remote

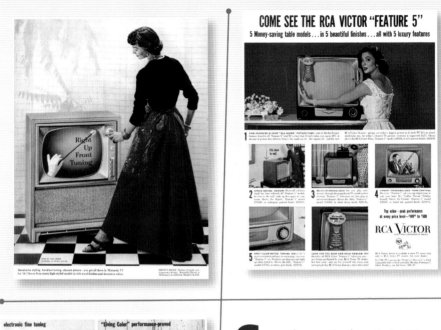

Stromberg-Carlson's 1953 "Classic" model television sounded more like a museum piece than a household item. It featured "individually designed cabinets, hand-decorated with authentic Chinese legend designs on ivory, red, or ebony lacquer," and bore the artist's signature.

Now—television can be more to you than a picture. As the center of interest in your home, it can also be a thing of beauty, a constant tribute to your good taste. In this Stromberg-Carlson Classic superb performance in sight and sound is combined with a masterpiece of truly fine cabinetry. Here too, is exciting Panoramic Vision—which only Stromberg-Carlson can give you!

"there is nothing finer than a STROMBERG-CARLSON."

The CLASSIC with exclusive PANORAMIC VISION has the widest viewing angle in 21 inch TV. Performance on UHF or VHF, even in fringe areas, is outstanding. Each cabinet is individually hand-decorated with authentic Chinese legend design on ivory, red, or ebony lacquer—and bears the artist's signature.

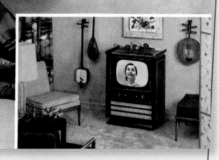

Stromberg-Carlson television is priced from $249.95 including excise tax and warranty. (Slightly higher in south and west). See classified pages of telephone book for nearby dealers.

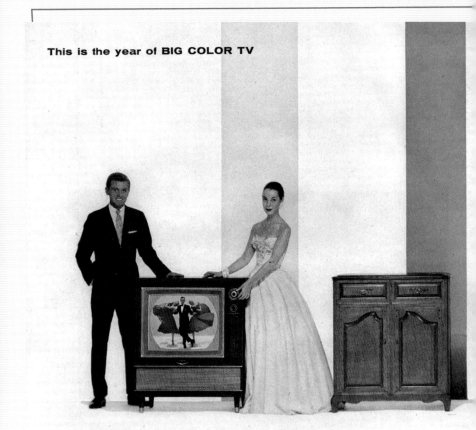

This is the year of BIG COLOR TV

Announcing **RCA VICTOR BIG COLO**

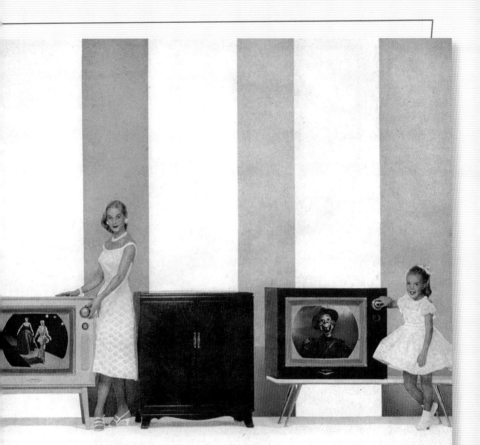

TV in 5 exciting styles, from $695

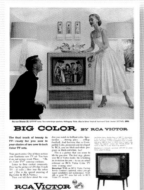

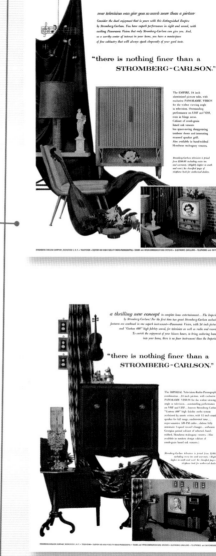

The first major color broadcast was the live telecast of the Tournament of Roses Parade in January 1954. Some other important firsts in color broadcasting history include the first color broadcast of a U.S. president (Dwight Eisenhower, June 1955), the first color coverage of the World Series (Dodgers vs. Yankees in September 1955), and the first color cartoons (*The Flintstones*, 1960–66; and *The Jetsons*, 1962–63).

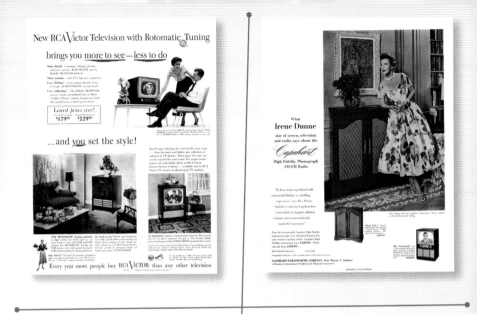

New RCA Victor Television with Rotomatic Tuning

brings you more to see—less to do

More detail—a stronger, sharper picture whatever you see. ROTOMATIC gift it, MAGIC MONITOR holds it!

More stations—with TV's big new expansion.

Less "dialing"—every station already tuned on target, all ROTOMATIC on one knob!

Less "adjusting"—The MAGIC MONITOR circuit system automatically ties in those "Golden Throat" sound, scenes out static and interference, controls power back.

Lowest prices ever!
$179.95 $229.95

...and you set the style!

UHF ROTOMATIC Tuning optional, is slight added cost. Both right or certain band or tuner lists UHF and VHF stations. On ROTOMATIC Tuning for UHF stations only, with normal timing for UHF stations optional on lower priced sets.

So much to see! Bethel and Continental sure styles should offer cabinetmaking our finest, luxury finishes. A rich cabinet for color, thirst, the new RCA Victor Predict, 21-inch console in mahogany finish, or hand-rubbed wood. Explore at the AVC85 list.

So handsome is needs a many-phased artwork it. You'll more or less a "TV place" wherever you put it. The 21-inch, Bethel pictured mahogany finish, 21590 $359.95 (optional blond center).

*See the 14-inch "Variada" TV Prevision listen. Let's 24 Alphas 21590.
For those chairs most wait RCA Victor TV or "Variada" (superb distinction), 81340.7*

Every year more people buy RCA Victor than any other television

What
Irene Dunne
star of screen, television and radio, says about the

Capehart

High Fidelity Phonograph
AM-FM Radio

"To hear music reproduced with concert-hall fidelity is a thrilling experience," says Miss Dunne. "And this is what my Capehart does. I can't think of a happier addition to home entertainment than this wonderful instrument."

Hear the incomparable Capehart High Fidelity instruments today. Low classified directory lists your nearest Capehart dealer. Capehart High Fidelity instruments from $129.95—Television sets from $169.95.

CAPEHART-FARNSWORTH COMPANY, Fort Wayne 1, Indiana
A Division of International Telephone and Telegraph Corporation

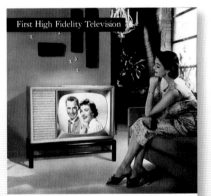

First High Fidelity Television

The Magnificent Magnavox
looks alive...sounds alive!

We promise you the sensation is new. For the first time, you feel the picture is real... alive... sweeping you into the scene. You are surrounded with natural sounds that let your eyes believe what your eyes are seeing. This only happens when true high fidelity pictures are matched with the finest high fidelity sounds. We've achieved it for you in the Magnificent Magnavox. And a demonstration is an experience you deserve. Come in and compare any Magnavox television instrument—its picture, its sound, its superb cabinetry—and then compare the price. Models from $149.50.

Above is the new 24" Cosmopolitan, with 3 high fidelity speakers. Its true high fidelity amplifier—10 times as powerful as ordinary television. Available in genuine Mahogany, solid Oak, Cherry or Walnut, with inlaid. At left, the Magnavium 21", with concealed top storing. Your Magnavox dealer's name is listed on the yellow pages of your telephone book. The Magnavox Company, Fort Wayne 4, Indiana.

Styled Television...with a Finger Tip Tuning System!

The simplest, most beautiful control center ever designed puts the

*WORLD'S FINEST TELEVISION PICTURE
RIGHT AT YOUR FINGER TIPS!*

With one sweeping advance, Philco has taken all of television's trick tuning devices into orbit of the past. No more grappling with awkward, unsightly trap doors... no groping for knobs behind the cabinet... no guessing as you fumble the rate of touch-side dials.

The distinctive new Philco Finger Tip Tuning System is a lone triumph of beauty and simplicity. Only 2 controls are visible on that streamlined panel—yet all controls are right at your finger tips. To get a complete command of the greatest power plays in all television. Everything you need to get TV's brightest, clearest picture on all channels—UHF and VHF.

His-flaming Philco's great new TV models is the widest sensation of the year—big, brilliant 24-inch television at a 21-inch price! And with Philco's Miniaturized Power on Bright picture tube (for richer contrasts—black to black) and whiter whites) you get 525 square inches of the finest television picture ever achieved. That's up to big screen Philco now.

Step in to your Philco dealer's today. See the greatest television values of all time—the most dramatic new Philco Custom-Styled models for '55. Brilliant new designs in space-saving cabinets, colorful new finishes, at the lowest prices in Philco history.

NO GRAPPLING
With Trap Door Panel

NO GROPING
Behind the Set

NO GUESSING
With "Blind" Side Dials

Philco Built-in Aerial
in up to 9 out of 10 locations you just plug-in and play

We select built-in aerial, regardless of price, can approach it for "picture" power.

FREE CUSTOM-STYLED STAND WITH THIS $199⁹⁵ RCA VICTOR OVERSIZE 21-INCH TV!

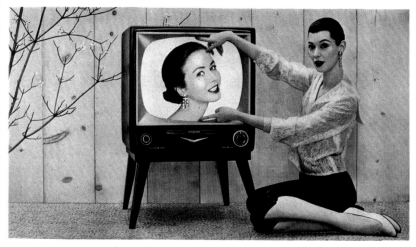

Big, big picture! Big, big value! Give your home (and your family) a big Spring "lift" with the handsome new RCA Victor *Dorrance*. You get TV with the biggest picture in 21-inch television—plus a *free* custom-styled stand—both for the low price of the set itself!

The *Dorrance* brings you advances like the new "Magic Monitor" chassis for TV's finest reception and rich, realistic "Golden Throat" Fidelity Sound. See these and other exciting new RCA Victor Spring Specials now at your dealer's. Above, the *Dorrance*. Model 21S510. In sleek ebony finish, $199.95. In rich maroon finish, Model 21S511, $209.95. (Matching stand included while the supply lasts.)

Free $14.95 matching stand is yours with these new table models. Low and stylish, the stands blend perfectly with any decor.

You get the famous "All-Clear" Picture! *Aluminized* to give you 212% greater picture contrast—it's the brightest and clearest picture in television!

New-design tuning dial is 59% more readable! King-size channel numbers slant up to meet your eyes. TV's easiest tuning!

PLEASE NOTE: RCA Factory Service is available in most TV areas, but only to RCA Victor TV owners. Ask your dealer. Suggested VHF list prices shown, subject to change. Slightly higher in far West and South. UHF optional, extra. Don't forget to see NBC-TV's spectacular "Producers' Showcase" in RCA Compatible Color or black-and-white, Monday, May 30. Other Mondays, see Sid Caesar, NBC-TV.

RCA VICTOR ® RADIO CORPORATION OF AMERICA

EVERY YEAR MORE PEOPLE BUY RCA VICTOR THAN ANY OTHER TELEVISION

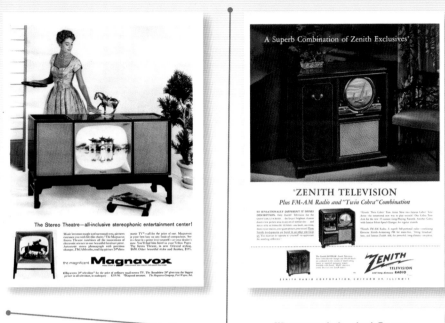

The Stereo Theatre—all-inclusive stereophonic entertainment center!

the magnificent **Magnavox**

*T*V Guide included free "TV Set Buyers' Guides" as special inserts for several years during the 1960s. The cover of its 1966 Buyers Guide shows a Carnaby Street model dashing along with one hand on her modish hat while holding her tiny portable TV in the other.

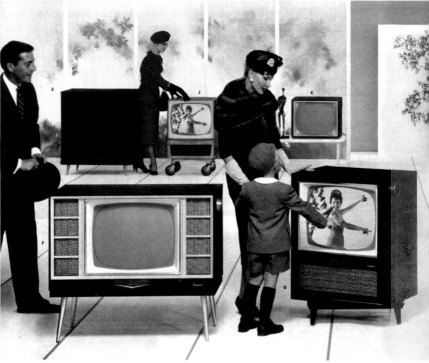

Originals by RCA Victor from $125

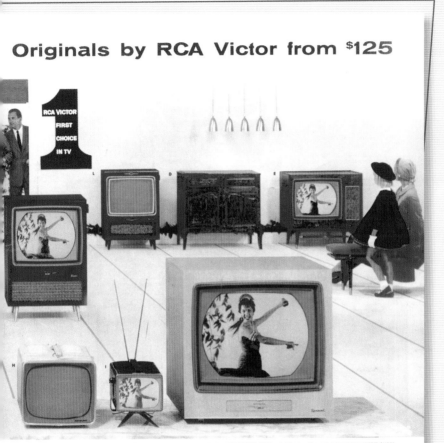

or limed oak-grained finishes. (21T741) $339.95. **G.** 261 sq. in.* **Enfield.** Mahogany-, walnut-grained finishes. (21T738) $299.95. **H.** 108 sq. in.* **Wayfarer.** Gray, red, or ivory finishes. (14570T) $149.95. **Sportster.** (not shown) Ebony finish. (14570SI) $129.95. **I.** 36 sq. in.* **"Personal."** Gray, red, ebony or ivory finishes. (8PT703) $125. **J.** 261 sq. in.* **Ardmore Deluxe.** Mahogany-, walnut-, limed-oak grained finishes. (21O721) $269.95. **K.** 261 sq. in.* **Dixon.** Ebony finish. (21O721) $219.95. Maroon and limed oak-grained finishes. (21T715) $229.95. **L.** 261 sq. in.* **Fenway Deluxe.** Mahogany-grained finish. (21O742) $309.95.

own eyes—Big Screen—from $495

Admire the new "Living Image" picture—in all sets from $129.95 . . . fine, clear blacks and whites . . . unbelievably sharp and crisp detail.
Visit your RCA Victor dealer for a whole new experience in home entertainment. Do it soon!

| *Square inches of viewable picture area | 36 | 108 | 254 | 261 |
| Picture tube, overall diagonal or diameter | 8" | 14" | 21" (diam.) | 21" |

FIRST IN BLACK-AND-WHITE TV—FIRST IN COMPATIBLE COLOR TV

Like having 2 sets in 1! This is RCA Victor *Compatible* Color TV. It brings you Color and black-and-white shows, too!

Manufacturer's nationally advertised VHF list prices shown. UHF optional extra (not available on "Personal"). RCA "Magic Brain" remote TV control for most black-and-white models, opt., ea. **At your service:** RCA Victor Factory Service Contracts available in most areas but only to RCA Victor owners. Special low-cost 1-year contract on "Personal" and portable — only $14.95. Color TV contracts as low as $39.95 (90 days).

Symbol of RCA Victor Compatible Color TV

RCA VICTOR
TMK ® RADIO CORPORATION OF AMERICA

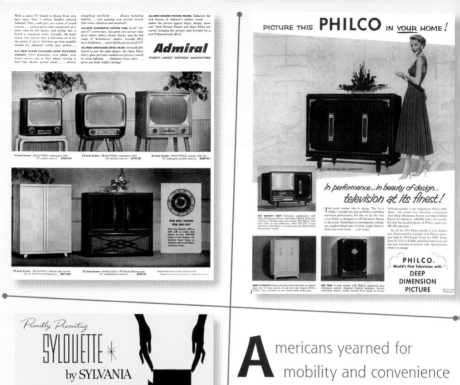

Americans yearned for mobility and convenience in the 1950s, and new interstate highways (along with the soon-to-be ubiquitous Holiday Inns and McDonald's restaurants) fit in perfectly. Portable TVs became the rage, although at first bulky picture tubes kept them more luggable than portable.

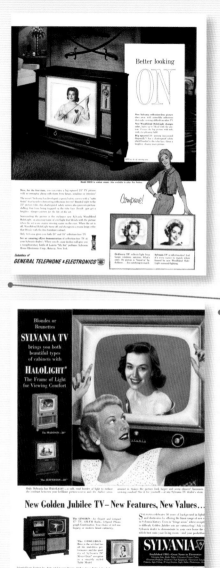

At the 1962 Seattle World's Fair, the General Electric (GE) exhibit, immodestly called "General Electric Living," was devoted to a push-button world. Looking inside GE's House of Tomorrow we found push-button phones, a private heliport, electronic bakery drawers, indoor pools and gardens, home computers, and wall-to-wall televisions.

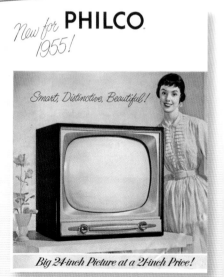

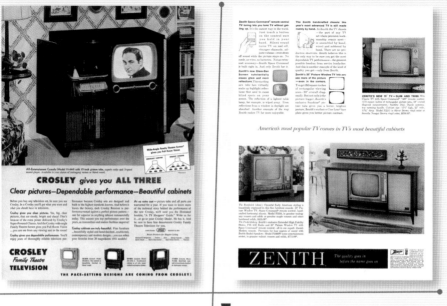

In 1961 RCA Victor introduced its seven-function remote-control color television. "So beautiful that it enhances any décor. Clean, modern styling, no knobs or gadgets in sight." What really set it apart though was the "amazing new wireless wizard remote control," through which you could control tint, color, brightness, volume, fine tuning, channel selection, and on-off.

"You can't go wrong with G.E.C."

SAYS EAMONN ANDREWS

We believe you will be impressed with this fine 14-inch receiver, its large
brilliant picture and the handsome walnut veneer cabinet. And
please remember that it matters a great deal who makes your
receiver. It is a highly technical instrument, and you must be
able to depend on the *hidden* parts. You are safe with G.E.C.,
one of Britain's great names in electrical engineering. Pioneers
of television, they never let their initials appear on any model
until it has passed the most rigorous tests in the laboratory,
in production and at work in all TV areas. *For details write
for Publication BT2073 The General Electric Co. Ltd.,
Magnet House, Kingsway, London, W.C.2.*

see all...hear all...so much better on

G.E.C. *television*

BT5147 **60 gns.** tax paid
or hire purchase.

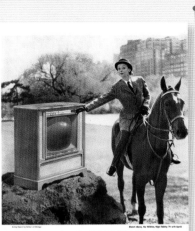

In pre-cable days TV antennae, whether mounted on your roof or attached to your TV indoors, were crucial to getting a good picture. If you lived in a city, you could probably get away with rabbit ears (V-shaped antennae emanating from a base that had a place of honor on top of your TV). But your problems didn't end there: to keep the reception sharp you had to regularly pop up from your seat to move the rabbit ears every which way.

In 1957 NBC's peacock appeared at the beginning of every color broadcast on that station, with the announcement, "The following program is brought to you in living color." In 1962 NBC gave the peacock a more modern look and enhanced its color and scaled down the musical score.

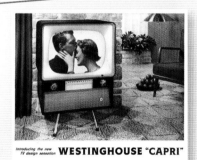

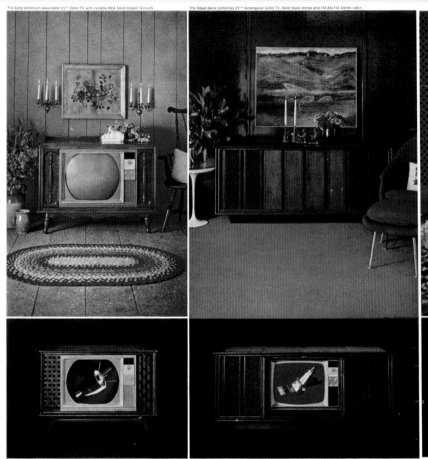

The Early American Gloucester 21" Color TV with reliable RCA Solid Copper Circuits.

The Royal Dane combines 25" rectangular Color TV, Solid State stereo and FM-AM-FM Stereo radio.

The Scandinavian-styled Lundberg 21" Color TV has Automatic Color Purifier, one-set VHF fine tuning. The Royal Dane, one of RCA Victor's finest cabinet creations, with doors that disappear.

America's most successful space programs have it; RCA Victor Color TV has it:

It's breathtaking. New RCA Victor Color TV. Even people who understand how it works watch it in awe. If those glorious colors don't convince you, wait a minute. There are two important things you *can't* see behind that beautiful picture.

One is reliability—the reliability of RCA Solid Copper Circuits. They replace old-fashioned handwiring in over 200 possible trouble spots. They won't come loose. Won't short-circuit. Won't go haywire. They're *solid*. And circuits used in some of NASA's most successful space programs are *solid*, too.

What *else* is behind that great color picture? Experience. RCA Victor has more experience in Color TV than many manufacturers have in making black-and-white sets. Stands to reason, doesn't it, that the one proved in the most homes will work best in yours?

Cabinet styles? See Spanish, Early American, Contemporary, Scandinavian, French or Italian Provincial — and more. All are faithful adaptations, rich in fine furniture detail, glowing with the beauty of magnificent woods and costly veneers.

Good reasons, aren't they, for looking at RCA Victor Color TV first? You'll see why more people own RCA Victor Color TV than any other kind. Shouldn't you?

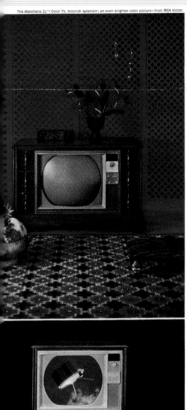

Perhaps more than any other show, *Walt Disney's Wonderful World of Color* (1961-69), a diverse program of cartoons, adventure, documentaries, and nature tales, persuaded folks to finally spring for a color television. Originally *Disneyland* and then *Walt Disney Presents*, the show made its color debut on NBC when Walt Disney's ABC contract expired. It featured a theme song by Richard M. Sherman and Robert B. Sherman, writers who went on to create scores for *Mary Poppins* and other well known Disney films.

A Friend of the Whole Family

From the very beginning, TV was a magnet for the family. Everyone wanted to gather around it to see what wonders would appear next. And it didn't really matter what was on; everything on TV was magical. Since programs were only on the air for a few hours each day, dzzads watched cartoons and kids watched *Texaco Star Theater*. As long as everyone was together and the TV was on, life was good.

As the 1950s moved on, TV programming offered more choices to individual family members. Mom might sneak in dinner preparations while the kids watched afternoon programming meant for them. Dad might come home and catch the headlines while Mom put dinner on the table and the kids finished up their homework. During the day Mom could make time for her favorite soap opera, sponsored by Procter and Gamble or Colgate-Palmolive. These daytime serials were favorites among suburban housewives who worked while watching the exciting traumas of those glamorous characters on *The First Hundred Years* or *Guiding Light*.

Game shows were fun, too. Who didn't dream of being *Queen for a Day*? Sure, the contestants had to share their sad stories, but the winner received such lovely prizes, including a crown and a velvet robe. What a thrill to root for your favorite unfortunate and to feel a deep satisfaction at seeing a hard-working woman receive some comfort and relief. Plus, for the mom who was young at heart, what fun it was to watch the kids dancing on *American Bandstand*! Such good, clean, wholesome kids, and that Dick Clark was a dreamboat.

Once the kids came home from school, they ruled the TV. Advertisers planted the seeds of desire once they learned what a rich and fertile ground these youngsters were. For the first time ever, children became the target of advertising, as companies learned just how much they influenced their parents' purchasing decisions. *The Howdy Doody Show* resulted in Howdy Doody dolls and toys, and the suburbs were filled with boys dressed like Davy Crockett and Hopalong Cassidy. Having the things we saw on TV only made the experience that much better.

Scores of local TV personalities filled the airways to form an extensive network of hometown shows, featuring cartoons, shorts, and a variety of children's characters.

Today, all over the country, groups of adults find community in the shared memory of the local TV of their youth. In Philadelphia, you can ask any fifty-year-old for a clear description of Gene London's *Cartoon Corners' General Store.* And anyone raised in New York during that same time frame knows who Officer Joe Bolton is.

Dad had his own programs, too. From the earliest days, sports spectaculars attracted the head-of-the-household to the TV. During the 1950s crime dramas such as *Dragnet* and *The Untouchables* gave Dad some favorite choices, and of course the real stars of 1950s programming were the Westerns. From *The Rifleman* to *Gunsmoke* and *Have Gun — Will Travel,* it was a man's world. The ladies were welcome to join, but no one could mistake who ruled this world and who the stars were. They were men — real men.

TV also began to play a role in bringing real life into the American home. In TVs earliest days, news coverage was relegated to a mere fifteen minutes, but the 1950s saw that time allotment expand to a full half hour. Bringing current events to the TV screen changed the course of those events. Perhaps the earliest example of this is the televised hearings of the House Un-American Activities Committee. Once average Americans saw the shadier side of Senator Joseph McCarthy's investigations, he began losing public support. In 1956 NBC brought Chet Huntley and David Brinkley together to cover the political conventions leading up to the presidential elections in November, and one of the country's most illustrious news partnerships began.

By 1960, when the first televised presidential debates let Americans compare, in real time, candidates John F. Kennedy and Richard M. Nixon, TV was a mainstay in American politics and current events. With the coverage of President Kennedy's tragic assassination in 1963, TV had forever claimed its place as the way Americans get their news.

Despite real-life uncertainties and strife, in the world where TV families lived and our families visited, everything was right. Father knew best, Mom created a happy home, and kids prevailed despite their childhood blunders. When wrongs could be corrected in 22 minutes with a good talk and a secure hug, it's no wonder at all that TV was a favorite companion for everybody.

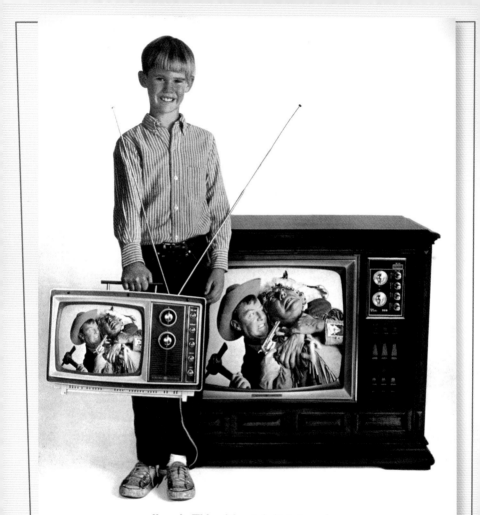

Now color TV doesn't have to be big to be good.

Take a look.

We've put every bit of our color console know-how into Porta-Color.

Unlike the big boys, Porta-Color can be carried around, from room to room, with one hand.

And it's half the price. $269.95.*

Of course, if you like big screen color that also happens to be a beautiful piece of furniture, tune in our color consoles with "Meter Guide" tuning.

It's a General Electric exclusive. It takes all the guesswork out of getting a good color picture.

In portable size or console size, G.E. gives you juicy color.

Still not sold?

Take another look.

GENERAL ELECTRIC

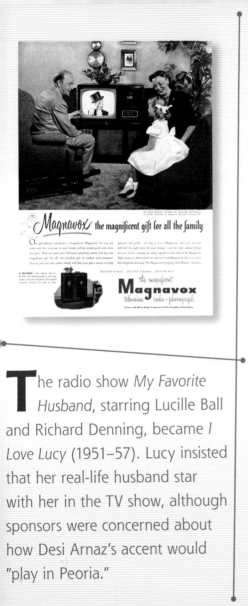

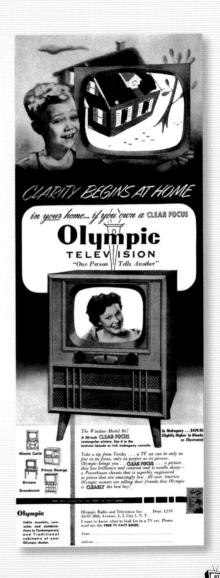

The radio show *My Favorite Husband*, starring Lucille Ball and Richard Denning, became *I Love Lucy* (1951–57). Lucy insisted that her real-life husband star with her in the TV show, although sponsors were concerned about how Desi Arnaz's accent would "play in Peoria."

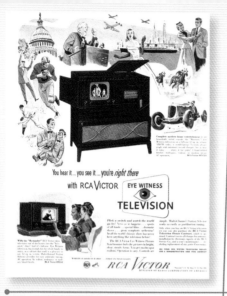

You hear it... you see it... you're *right there*
with RCA VICTOR — EYE WITNESS TELEVISION

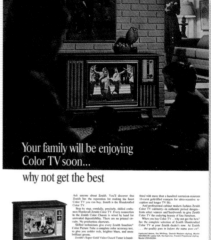

Your family will be enjoying
Color TV soon...

why not get the best

How research fits television into more purses

RADIO CORPORATION of AMERICA
World Leader in Radio – First in Television

The first nighttime soap opera, *Peyton Place*, ran from 1964 to 1969 on ABC. Set in the fictional New England town of Peyton Place, it starred Dorothy Malone, Mia Farrow, and Ryan O'Neal in an extensive all-star cast. The show went further in exposing the delicious secrets of small-town scandal first introduced by Grace Metalious in her best-selling novel with the same name.

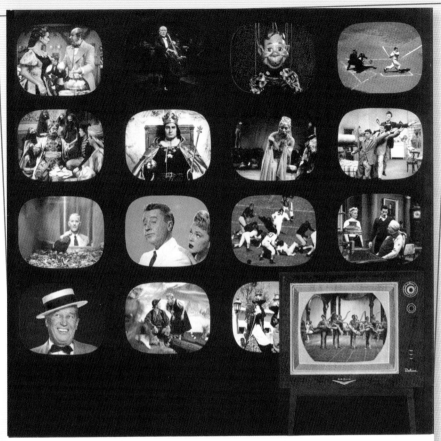

And wait till you see them exactly as they are planned and produced — with the bright costumes, the vivid sets, the actors and actresses in all their glowing vitality!

It's all happening right now, on NBC. Hard to believe? Sit down before a Color TV set and *see* it happening — *before your very eyes.*

Exciting things are happening on

NBC TELEVISION **RCA**

a service of

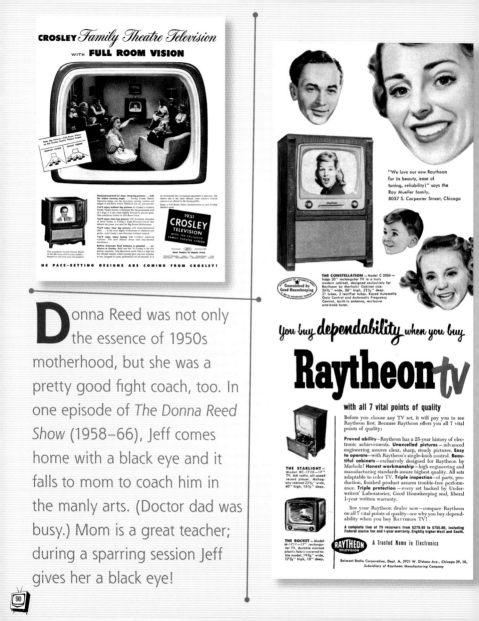

D onna Reed was not only the essence of 1950s motherhood, but she was a pretty good fight coach, too. In one episode of *The Donna Reed Show* (1958–66), Jeff comes home with a black eye and it falls to mom to coach him in the manly arts. (Doctor dad was busy.) Mom is a great teacher; during a sparring session Jeff gives her a black eye!

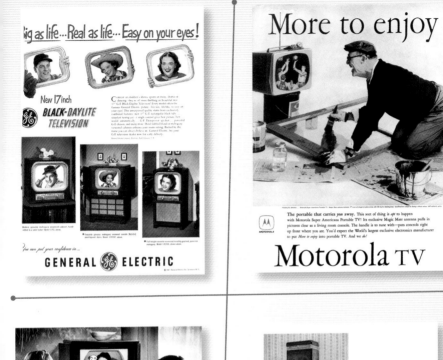
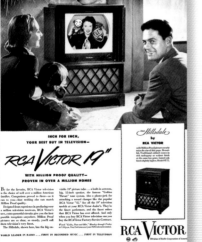

Your utility brings
low-cost HOUSEPOWER
right to your door...but

STEAM TURBINE GENERATOR

Is your home <u>wired</u> to
of modern electric

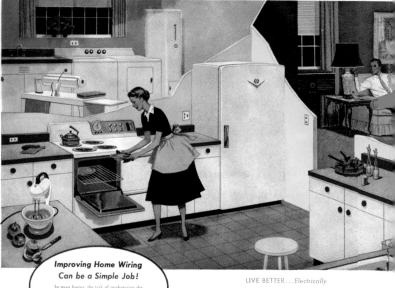

Improving Home Wiring
Can be a Simple Job!

In most homes, the task of modernizing the
electric wiring system is relatively simple and
inexpensive. Your local electrical contractor
can often do the job quickly and easily with-
out disturbing your daily living routine.

LIVE BETTER...*Electrically*
National Electrical Week, February 9-15, 1958

POWER TRANSFORMER CIRCUIT BREAKER LOCAL SUBSTATION POLE TRANSFORMER

ke full advantage
ving?

HERE ARE some of the ways you can spot inadequate wiring in your home:

. . . lights go dim when appliances are used.
. . . the television picture shrinks and expands.
. . . the toaster or iron heats up too slowly.
. . . fuses blow out frequently.
. . . several appliances plugged into one outlet.

All of these are warnings that your wiring is overloaded . . . that you're risking trouble. Without modern wiring, your present household appliances can't operate at their best . . . and you can't enjoy many of the new appliances available today.

* * *

All along the power line, from power plant to you, your utility uses the most modern equipment—like the Allis-Chalmers units shown above—to bring an abundant flow of low-cost electric power *right to your door.*

Beyond that point, it's up to you. Be sure *your* home is wired to take full advantage of modern electric living.

ALLIS-CHALMERS ◆AC◆

Where Engineering in Action is at work on your future—today

A PICNIC FOR POP

an easy-going adaptable personality that matches the moods of his family or his large circle of friends.

The snappy pappy This peppy Poppa keeps things popping for the whole family! Sure, he likes things played his way, but *he* plays 'em for laughs—so all hands have a good time *any* time he's aboard.

All color photos on ANSCOCHROME

"**The Ten Commandments**" in VistaVision. See **Glenn Ford** in MGM's "**Don't Go Near The Water**" in CinemaScope

For fun they can tote—at home or afloat—THE STARS SAY "AYE" TO THE ADMIRAL!

When they want perfect, pleasure-filled "takes"—on land or sea—our celebrities always take along an Admiral. Charlton Heston carries the new Admiral 8 Transistor Portable with "Roto-Scope" Antenna. Eight transistors replace tubes for a lifetime of service. Long-range power pulls in even weak, distant stations with maximum clarity. In handsome, rugged steel-and-leather case. Admiral radios from $15.95.

Glenn Ford's lightweight Admiral 17" Portable gives big-set reception anywhere—bedroom, kitchen, or on a trip...it's America's Number 1 BIG SCREEN portable! Tests prove Admiral's exclusive "Power-Plated" Chassis locks in a sharp, clear picture that stays perfect—even after the jolts and jars a portable takes. One-piece wiring and connections just can't shake loose. Admiral Portable TV from $89.95.

It's Admiral for the perfect gifts for Dad, the graduate, June Bride, and on every gift occasion. **Turn back one page to see other fine Admiral Portables.**

Admiral® PORTABLE RADIO AND TELEVISION

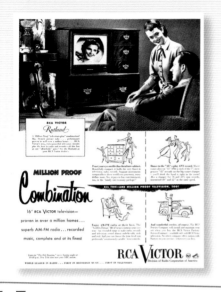

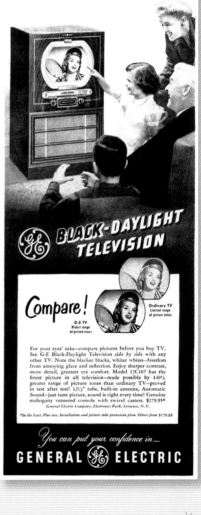

Howdy Doody for president?
That's right. The goofy puppet
ran for office in 1948. Shamelessly
using his own show to promote his
candidacy, he garnered over 400,000
votes from his small-fry audience.
So in 1949 he was inaugurated as
"President of All the Kids in the
United States." He ran for re-election
in 1952 and, as luck would have it, he
won again. It was Howdy Doody time
for four more years.

HALOLIGHT® brings Eye Fidelity to TV

keep your eye on SYLVANIA...fastest growing name in sight!

see them all FREE...see them BETTER!

GE BLACK-DAYLITE TELEVISION
pays for itself over and over!

$200,000,000 worth of Talent!

GENERAL ELECTRIC

The look you'll never forget
with **RCA VICTOR** *Million Proof television*

It's Million Proof
—proven in over *3ine* million homes

RCA VICTOR
World Leader in Radio...First in Recorded Music...First in Television

Hopalong Cassidy (1949–51) was TV's first hit Western. It was inspired by a series of Saturday movies, called "horse operas" by some, that ran in theaters across the country.

x

IN '56 ADMIRAL TV

Performance and Dependability
MEN look for...

Admiral's great new Super Cascode Power Plant has extra tubes and circuits for greater signal-pulling power anywhere— in the city or 'way out in the "fringe." And absolute uniform quality and dependability is assured. More than 75% of the chassis is assembled automatically by revolutionary new *precision* machines that eliminate chances for error in manufacturing.

To assure *picture* quality, *aluminized picture tubes in every model* give you twice the brightness and contrast! Admiral's Optic Filter Screen makes blacks blacker . . . eliminates harsh glare.

You can own 1956 Admiral TV for as little as $1.87 weekly

Admiral.

choice of 5 million TV owners

TWIN TV ACHIEVEMENTS!

First with Printed Circuit TV! Over 75% of TV chassis circuits are "printed" on new electronic panels!

First with Automation! Assembly by new Admiral-designed automatic machines assures uniform quality, eliminates chances for error!

local paper for time and stations.

Slightly higher South and West...Fed. Tax, warranties included ... all prices higher in Canada ... subject to change without notice.

NO STOOP!

21" TV—The Mediterranean. With lighted Top Front Tuning, new Super Cascode Power Plant, aluminized picture tube and tinted Optic Filter. Full-fidelity sound system with 6" x 9" Alnico Speaker—all '56 features. Blonde oak or mahogany finishes. 27" screen size also available in similar cabinet.

NO STRETCH!

21" TV—The Montreal. New Super Cascode Power Plant, Top Front Tuning, aluminized picture tube and tinted Optic Filter. Stunning decorator cabinet on graceful golden-tipped legs. In rich bronze mahogany finish, traditional mahogany finish (illustrated), or modern blonde oak finish.

NO STRAIN!

24" TV—The Sweden. With all '56 features, including aluminized picture tube and tinted Optic Filter—plus exclusive Periscope Dial that shows lighted magnified channel numbers through cabinet top! Twin 6" x 9" Speakers. Blonde oak or mahogany. Also with 21" screen, mahogany or blonde oak.

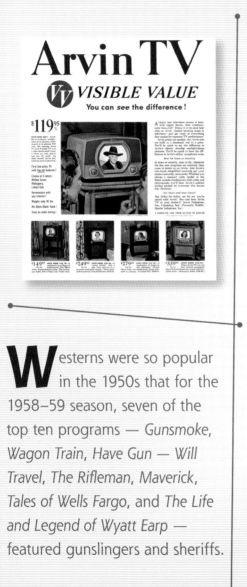

Westerns were so popular in the 1950s that for the 1958–59 season, seven of the top ten programs — *Gunsmoke, Wagon Train, Have Gun — Will Travel, The Rifleman, Maverick, Tales of Wells Fargo,* and *The Life and Legend of Wyatt Earp* — featured gunslingers and sheriffs.

A.C. Nielsen's first listing of top-rated TV shows was for October 1949. It included, in order, *Texaco Star Theater* (1948–56), *Toast of the Town* (1948–55), *Arthur Godfrey's Talent Scouts* (1948–58), *Fireball Fun for All* (1949), *Philco Television Playhouse* (1948–54), *The Goldbergs* (1949–55), *Suspense* (1949–64), *Ford Theater* (1949–57), and *Cavalcade of Stars* (1949–52).

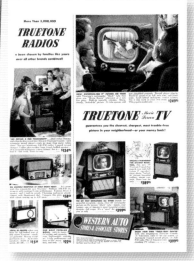

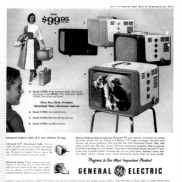

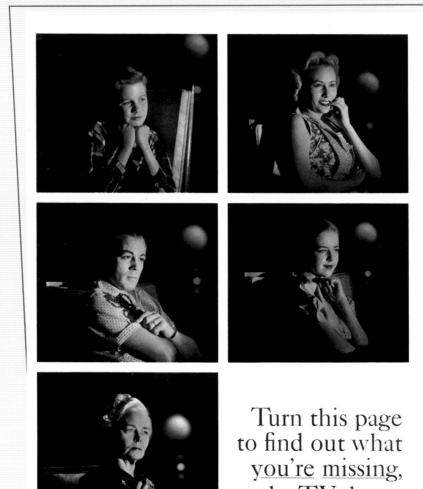

Turn this page
to find out what
<u>you're</u> <u>missing</u>,
on the TV shows
you never miss!..

the big thrill of
BIG COLOR!

Why miss it another day? Whatever kind of program *you* like best, see it glowing and vibrant in a new light! Here's the wide and wonderful choice of Big Color TV shows on NBC . . . in the month of June *alone*.

Eighteen full-hour plays, live from Hollywood on MATINEE THEATER! A SUNDAY SPECTACULAR! MAX LIEBMAN PRESENTS *"Sweethearts"! A 90-minute production of "Happy Birthday" on* PRODUCERS' SHOWCASE! THE MILTON BERLE SHOW! *And that's not all! All these top-rated NBC programs are giving one or more Big Color performances during June, too!* KRAFT TELEVISION THEATER! GOODYEAR PLAYHOUSE! THIS IS YOUR LIFE! THE COMEDY HOUR! THE DINAH SHORE SHOW!

Yes, NBC is color-vising the kind of programs *you* like . . . right now! And by the end of summer, NBC will bring you at least one Big Color TV program *every evening!* You can, of course, enjoy them all in black and white. But discover NBC Big Color and you'll see how much you've been missing . . . on the shows you never miss.

NBC TELEVISION

exciting things are happening on ——————— *a service of* 🅡🅒🅐

Here's Where The Family's Living Now!
...it all started with Television and Texfloor!*

When that TV set moved into Dad's old den . . . so did Mom and the kiddies! Now it's the family favorite—redecorated with a charm that invites everyone to come early and stay late.

Look how the den's new inviting mood starts with the handsome floor. It's Sloane Quality TEXFLOOR tile—*the new linoleum with the textured look*. The soft woven appearance of Texfloor gives any room a delightful feeling of being designed for living.

And what a carefree feeling Texfloor creates! You *know* Texfloor will wear and wear. You *know* smooth Texfloor will stay sparkling and spotless with only an *occasional cleaning.*

Ask your Sloane-Blabon dealer about lovely Texfloor. You'll get a wonderful feeling when you discover *how little it costs* to have beautiful, serviceable, easy-to-clean Texfloor in your home.

PLAN ROOM-TO-ROOM COLOR SCHEMES WITH TEXFLOOR!
Texfloor is available in a Color Coordinated Group of inlaid patterns, jaspé floor covering and tile. See them all at your Sloane-Blabon dealer.

SEE HOW YOUR OWN DESIGN IDEAS WOULD ACTUALLY LOOK! ASK YOUR DEALER OR SEND FOR NOVEL DESIGN-A-FLOOR KIT!

SLOANE
Quality
LINOLEUM PRODUCTS

for better design and truer color

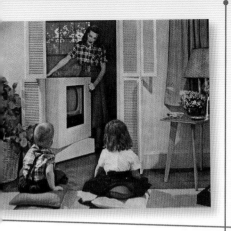

Ed Sullivan had an uncanny ability to spot rising stars. His first show, *Toast of the Town*, which debuted in 1948, starred the mostly unknown duo of Dean Martin and Jerry Lewis. The show's total budget was $1,375.

Local stations have always been able to capture the flavor and cadence of their markets, something that national networks were not able to do. Local stations gave starts to some of TVs biggest stars, including Ernie Kovacs and Dick Clark in Philadelphia; Dave Garroway and Fran Allison in Chicago; and Liberace, Alan Young, and Betty White in Los Angeles.

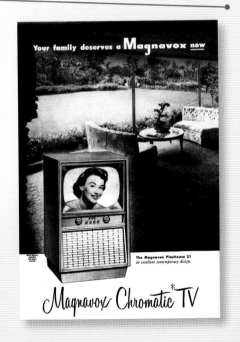

Sparton TV's <u>Top Tuning</u> Is The Answer To A Lady's Prayer

Read why a frank letter from a practical lady caused Sparton TV's designers to give you wonderfully convenient top tuning.

The letter was brief and to the point. "Dear Sparton TV," it began. "Why don't you people realize that the sight of a woman tuning a TV set with that near the floor is embarrassing and undignified? Please design a set with dials near the top of the set. Thank you."

Sparton designers agree

First our designers smiled. Then they thought about it again—and went to work. The result is the wonderfully convenient —and very handsome—Sparton TV Top Tuner.

Top tuning, by itself, is not reason enough to buy a Sparton TV set. But it is just one of Sparton TV's custom-built advantages. Did you know that Sparton TV's famous cabinets are hand-rubbed by veteran cabinet makers?

Custom-built chassis

And Sparton TV recognizes the fact that brilliant styling and superb cabinets are just the beginning of a great television set. The heart of the matter is the chassis, and that's where Sparton TV's custom-built features really go to work for you. Every electrical connection in a Sparton TV set is hand-soldered—to give you the clearest reception known to science.

If you want the advantages of custom-built television at a reasonable price—Sparton prices start as low as $169.95—stop in and have a talk with your Sparton TV dealer. He'll give you an idea of the special kind of enjoyment and satisfaction that comes from owning a Sparton TV set.

SPARTON TV

Sparton Radio-Television Division,
The Sparks-Withington Co., Jackson, Mich.

By the early 1950s, TV repair had become a big business, employing nearly one hundred thousand people.

The big idea at the Palm Club is to give each family a home that is ideal, truly ideal. Nothing less.

As Braider West puts it, "We're building the end of the rainbow, right here in Pompano Beach." To back up his claim, he has provided a yacht basin, swimming pool and private beach and club facilities. And he installs in every home RCA Whirlpool appliances in color and an RCA Victor Factory "Living Color" TV Not as extras, mind you, but as standard equipment, all installed with trouble-free performances...

assured in an RCA Factory Service Contract. Though Mr. West is the first builder in the nation to take this significant step, he is confident that there will be many builders to follow. "With today's trend toward convenience and gracious living, the choice of RCA Whirlpool appliances is natural," says Mr. West, "and with the spectacular development of color in television, RCA Victor Color TV is a must."

Why not enjoy these new standards of easy living in your home? As RCA Victor or RCA Whirlpool dealer is the man to see today.

RCA VICTOR **RCA Whirlpool**

Doing household chores in the company of a television was a lot more fun once the first daytime soap opera, *These Are My Children*, debuted on NBC in 1949.

WHERE DID THE MORNING GO?

Time for lunch already?
Where did the morning go?
The chores are done, the
house is tidy ... but it hasn't
seemed like a terribly
tiring morning.

First there was breakfast, and that was pleasant. We all got the news from "TODAY," and Dave Garroway had some fascinating guests. The children were still laughing about J. Fred Muggs when they left for school.

Then I sat Kathy down in front of "DING DONG SCHOOL" and I didn't have to worry about her while I tidied up. Miss Frances got her interested in finger-painting, and after the program Kathy just went on playing quietly.

"WAY OF THE WORLD" had the second installment of the new story, and I couldn't miss that. It's like a magazine serial — you keep looking forward to the next episode. And beautifully acted, with new stars for every new story.

I think I started the ironing while I watched "THE SHEILAH GRAHAM SHOW". First she discussed the latest Hollywood news and gossip. Then she interviewed William Holden, and showed parts of his exciting new movie.

And I finished the ironing while I watched "HOME". I couldn't *count* the good ideas I've had from Arlene Francis and her expert assistants on health, home decorating, gardening and food. I added a few things to my shopping list.

Any morning of any day, "THE TENNESSEE ERNIE FORD SHOW" can brighten things up for me. Tennessee Ernie and his talented friends joke, sing and share the fun with everyone . . . at the studio and at home.

And then "FEATHER YOUR NEST", where that lovely couple won a living room suite, and Bud Collyer and Janis Carter were so nice to them. And I think that it's a wonderful idea that viewers at home can win prizes, too.

The morning was a pleasure instead of drudgery. And yet I have everything done . . . I haven't really wasted a second. It's the way I like to have the morning go.

EXCITING THINGS ARE HAPPENING ON

NBC
TELEVISION
a service of (RCA)

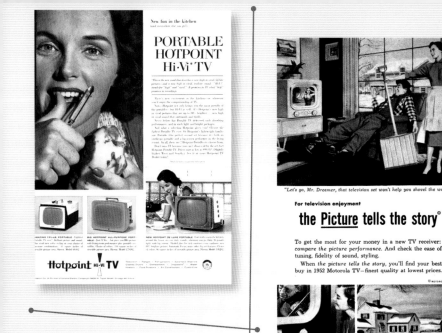

Bob Keeshan, who played Clarabell the Clown on *The Howdy Doody Show*, left the show in 1953 to start his own show, *Captain Kangaroo.*

NOVOLESCENCE*
means convenience!

TELEVISION is but one of the many reasons
why the New Yorker is a bargain-buy
among New York hotels. Add to this its
greater convenience, service and
continuing program of novolescence and
you'll understand its popularity!

HOTEL
NEW YORKER
34th St. at Eighth Ave., New York, N. Y.
Frank L. Andrews, President

*Novolescence—a word coined to describe our $2,000,000 improvement
program; new decor, new furniture, new value.

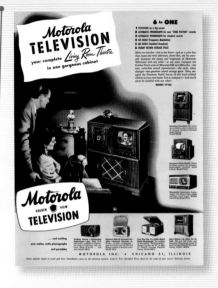

Motorola
TELEVISION
your complete Living Room Theatre
in one gorgeous cabinet

6 in ONE
1 TELEVISION on a big screen
2 AUTOMATIC PHONOGRAPH for new "LONG PLAYING" records
3 AUTOMATIC PHONOGRAPH for standard records
4 FM RADIO (Frequency Modulation)
5 AM RADIO (Standard Broadcast)
6 ROOMY RECORD STORAGE SPACE

Make no mistake—this is the finest—and at a price less
than many sets with television alone! But, see for your-
self. Compare the clarity and brightness of Motorola
Television with any other—at any price. Compare the
Golden Voice tone of Motorola FM and AM radio—the
rich, color-free sound reproduction—the rich, deep
charge—the generous record storage space. Then, con-
sider the furniture styled beauty of this hand-rubbed
cabinet in your own home. Test it, compare it—and you'll
never be satisfied with any other!

MODEL VP102

Motorola
GOLDEN • VIEW
TELEVISION

...and exciting
new radios, radio-phonographs
and portables

MOTOROLA INC. • CHICAGO 51, ILLINOIS

Prices slightly higher in south and west. Installation extra on all television receivers. Look in Your Classified Phone Book for the name of your nearest Motorola Dealer.

Smart idea in TV too... and G.E.
makes it smart for you!

Now you can have **two** of the
new advanced G-E TV for **less**
than millions paid for one

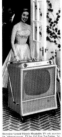

$99.95

Progress Is Our Most Important Product

GENERAL ELECTRIC

NEWEST
GENERAL ELECTRIC
PORTABLE TV...

56% BIGGER PICTURE

Progress Is Our Most Important Product

GENERAL ELECTRIC

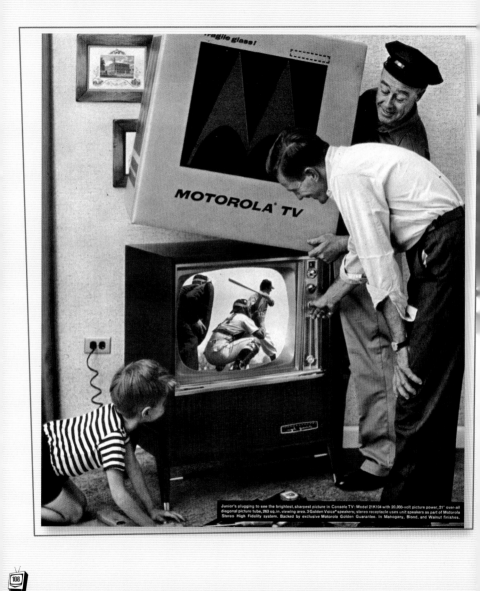

Junior's plugging to see the brightest, sharpest picture in Console TV: Model 21K104 with 20,000-volt picture power, 21" over-all diagonal picture tube, 263 sq. in. viewing area. 3 Golden Voice* speakers; stereo receptacle uses unit speakers as part of Motorola Stereo High Fidelity system. Backed by exclusive Motorola Golden Guarantee. In Mahogany, Blond, and Walnut finishes.

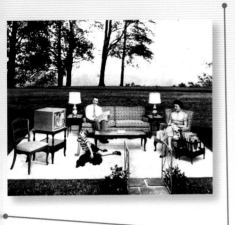

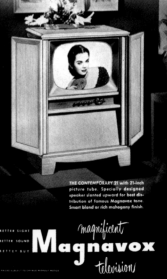

Dave Garroway, resplendent in bow tie and suit, introduced the groundbreaking *Today* show in 1952. Critics couldn't get a beat on the show and audiences weren't ready to add it to their morning routines, either. Enter baby chimpanzee J. Fred Muggs in 1953. Kids tuned in by the millions to watch the monkey business and brought their parents along with them. Ratings skyrocketed and the show is still a morning ritual today.

Polls showed that in 1963, for the first time, more people cited TV rather than newspapers as their

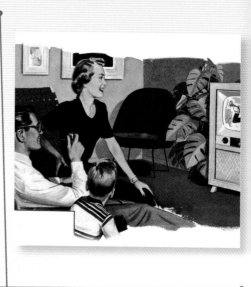

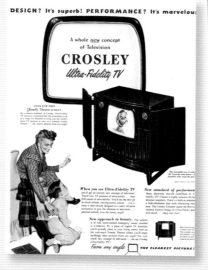

In 1960, for viewers "frozen to their TV sets," *TV Guide* suggested quick and easy "armchair dinners." These meals included meat patties and mushroom sauce and chicken-and-noodle casserole. For dessert it offered recipes for delights such as donut bites and soft ice cream.

Superb...

STEWART-WARNER
for Tone and
Picture Detail

Finest by far . . .
Stewart-Warner
21" TV with exclusive
THUNDERBOLT Unit-
Assembled Chassis . . .
perfect picture detail, full
rich tone, trouble free
performance. Beautifully
styled cabinets finished in
Mahogany or Blonde Oak.
Full UHF/VHF coverage.
Other 17", 21", 24", 27" TV
console and table models.

STEWART SW WARNER

*Stewart-Warner Electric
Chicago · in Canada,
Belleville, Ontario*

STEWART-WARNER
Your Theater of the World

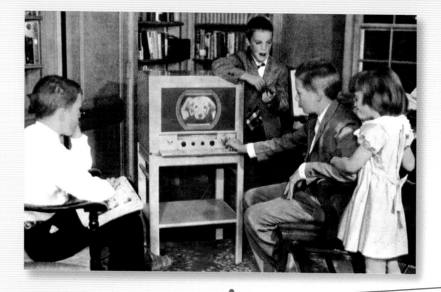

After school the kids took over the family TV. They sat down with their milk and cookies and watched shows like *The Howdy Doody Show* (1947–60), *Kukla, Fran, and Ollie* (1948–57), and *Captain Kangaroo* (1955–84).

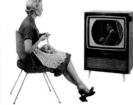

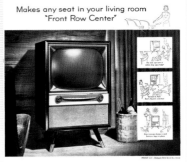

If you were a fan of *Bewitched* (1964–72) you may remember that Endora just could not seem to get Darrin's name right. Some of her best misnomers are Darwin, Darius, Durwood, Dagwood, Dum-Dum, Derrick, and Dobbin.

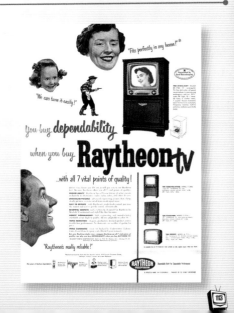

only 2 simple controls

TURN IT ON (⦿) - (⦿) **SELECT STATION** -that's all!

BRAND-NEW and BEAUTIFUL CONSOLE gives life-size pictures at lower cost!

BILT-IN-TENNA
No outside antenna in good signal areas.

16" BROADVIEW SCREEN
Life-size pictures of startling new clarity.

Want your TV BIG? Want it BRIGHTER and CLEARER than ever before? Want it in a BEAUTIFUL mahogany or limed oak cabinet? Then ask your dealer for a demonstration of the new Motorola 16K2. It's one of a *brand new* line of magnificent Motorola's—more handsome—better performing and yes, LOWER PRICED— 8½ to 19½ inch screen sizes—to fit every home and budget. *See them soon!*

See your classified directory for your nearest Motorola dealer.

Motorola TELEVISION

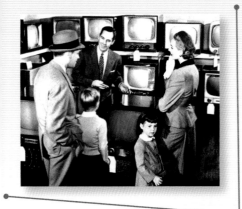

The 1950 *Hank McCune Show* will be remembered for two things, which may or may not be related: it was the first show to feature a laugh track (spliced-in audience laughter when supposedly funny stuff happened), and it was one of the first shows to be cancelled in mid-season.

In the 1950s, *TV Guide* answered the burning question, "Which TV cowboys can really ride?" Various wranglers rated these stars as "horsewise": Dennis Weaver (*Gunsmoke*, 1955–75), George Montgomery (*Cimarron City*, 1958–60), and Richard Boone (*Have Gun — Will Travel*, 1957–63). Riders who were only "pretty fair" included Hugh O'Brian (*The Life and Legend of Wyatt Earp*, 1955–61), Chuck Connors (*The Rifleman*, 1958–63), and Fess Parker (*Davy Crockett*, 1954–55).

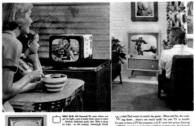

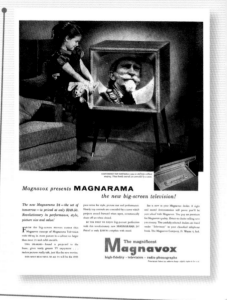
As if the first space missions weren't exciting enough, live shots pushed the excitement level over the top. Schoolkids packed into auditoriums to watch the blastoffs. TV was also there at the end of each mission for the capsule recovery.

Wherever you look...there's Emerson

Bound for Mars in the backyard space-ship...headed upstairs, downstairs, or across the continent...you're bound to enjoy a better view with the new Emerson Portable TV Model 1168. Here's a world of sparkling entertainment as portable as your personality...and just as easy to take along. It's AC-DC with built-in antenna. And Emerson's exclusive Dyna-Power chassis gives you big, bright, movie-clear pictures wherever you chance to be. Trouble-free, it costs *half* as

much to operate, parts last up to *ten* times longer. Leatherette traveling case resists scuffs and scratches...$128.

In case the Martians want to dance or listen to a ball game, little Rollo has brought along the Emerson "Never-Break" 3-way portable radio, Model 833. Runs on AC, DC, or batteries. Case guaranteed unbreakable or your money back. Choice of colors $34. *And wherever you look...look for Emerson TV, radios, phonographs, air conditioners.*

Over 16,000,000 satisfied owners

Emerson

Emerson Radio & Phonograph Corp., Jersey City, N. J. *Reg. U. S. Pat. Off.

Here are some TV theme songs that made it to Billboard's top one hundred: "Batman" (1966, #35), "The Beverly Hillbillies" (1962, #44), "Bonanza" (1961, #19), "Dragnet" (1953, #3), "Hawaii Five-O" (1969, #4), "Mission Impossible" (1968, #41), "My Three Sons" (1961, #55), "Route 66" (1962, #30), and "Secret Agent" (1966, #3).

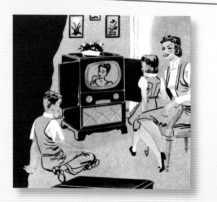

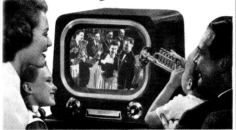
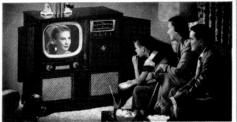

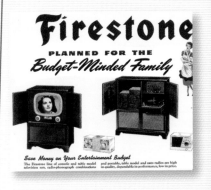
R od Serling is famous for *The Twilight Zone* (1959–64), but it turns out he wasn't the first to use that phrase to describe an otherworldly dimension. "The Twilight Zone" is an Air Force term that refers to the moment a plane's pilot can't see the horizon when a plane is descending on approach.

A Holiday Treat

A brand-new TV was the ultimate holiday present in those early years. Of course, TVs were still so expensive that it was most likely the big gift everybody shared. But what a gift it was! Not only did it make the holiday especially memorable, but it was also there for us day after day to bring pleasure and enjoyment. Sometimes it was Grandma and Grandpa who made this thrill possible, or the kids who all chipped in to delight the older folks. Whether it was the family's first set, first color set, or just a larger or portable TV, nothing made a holiday as special as a new television.

Soon after TV became a fixture in our living rooms, special TV programming started to help us celebrate the holidays. In 1950 the first Macy's Thanksgiving Day Parade was telecast nationally. Everyone from coast to coast could — and still can — enjoy this New York Thanksgiving tradition. The sight of those huge floating balloons and the jolly man in the red suit at the parade's end brought promises of the wonderful treats just weeks away.

In 1953 Bob Hope's first Christmas special was aired, and we celebrated the holidays with him for many years thereafter. Andy Williams, Perry Como, Mitch Miller, Bing Crosby, and other entertainers followed his lead, adding to the endearing place of TVs in our homes and traditions.

Regular programs got into the act, too, and before we knew it, every series featured a special

Quality TV

holiday episode. We celebrated Christmas with our friends from *The Andy Griffith Show* in Mayberry and with the Clampetts of *The Beverly Hillbillies*. The TV family extended from sea to shining sea!

Programs came into being just for the purpose of marking the holidays. In 1965 *A Charlie Brown Christmas* started an annual tradition that continues today. Just one year before, Burl Ives offered his own special take on the story of *Rudolph the Red-Nosed Reindeer*, and one year later, Dr. Seuss's *How the Grinch Stole Christmas!* explored Who-ville and its mean green neighbor. Not only do these shows give us all a holiday lift, but they also provide us with a common tradition of seasonal celebration, no matter which holidays we observe at home.

Advertisers and sponsors bought into the marketing opportunities of this gift-giving time of year, creating special campaigns of good cheer and deep discounts. Some of the best-selling toys of the 1950s and 1960s holiday seasons included Hasbro's Mr. Potato Head (1952), Rainbow Craft's PLAY-DOH (1956), Ohio Art's Etch-A-Sketch (1960), Kenner's Easy-Bake Oven (1963), Hasbro's G.I. Joe (1964), and Milton Bradley's Twister (1966). It was Mr. Potato Head's 1952 TV campaign (which helped sell $4 million dollars worth of the dashing spuds) that started toy manufacturers thinking about TV.

Before the season was over, we enjoyed one last thrill as we watched the beautiful Tournament of Roses Parade on New Year's Day. With the cold, harsh winter covering most of the country, what a wonderful relaxing treat it was to settle in for the special event in sunny Pasadena, California. It might be back to work and school on the 2nd, but New Year's Day lingered in our memories with those beautiful flower-decked floats and those precision marching bands. And like the gift that keeps on giving and the friend who's always there, TV glowed warm through January and all the months that followed until the holidays returned once again.

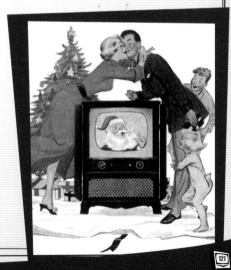

Now <u>everybody</u> can see Christmas in a new light! Every night of the holiday season you can watch thrilling NBC Big Color TV shows like this brand-new ninety-minute musical version of "A Christmas Carol" by Charles Dickens. It has a great all-star cast and it's called "The Stingiest Man In Town."

YES, THERE IS A SAN-TA CLAUS *for child-ren* ... *Though*

you may watch the chim - ney - tops

there.

See the Theatrical Enterprises presentation of "The Stingiest Man In Town", produced by Joel Spector, on The Alcoa Hour, Sunday, December 23. It's a special 90-minute show, starring Vic Damone, Johnny Desmond, the Four Lads, Patrice Munsel, Basil Rathbone and Robert Weede, with Martyn Green, Betty Madigan, and Robert Wright.

But you can start seeing Christmas in a new light long before "The Stingiest Man In Town" does. Here are just a few of the special holiday treats NBC will color-vise this month:

December 8, *The Warner Fashion Show.* December 10, *Festival of Music.* December 16, *Dinah Shore's Chevy Show.* December 22, *Sonja Henie's Ice Carnival.* December 24, *Amahl and the Night Visitors.*

And there are big Christmas shows planned for most of the regular programs NBC color-vises every week—like Noah's Ark, The Perry Como Show, Robert Montgomery Presents, Kraft Television Theatre, The Jonathan Winters Show, Lux Video Theatre, and The Walter Winchell Show. And a bright new year of Color begins on New Year's Day with a color-cast of the fabulous Tournament of Roses Parade.

Make this the Christmas your family will always remember with a special glow. Ask Santa to deliver your new Color Television set early.

NBC COLOR
TELEVISION
a service of RCA

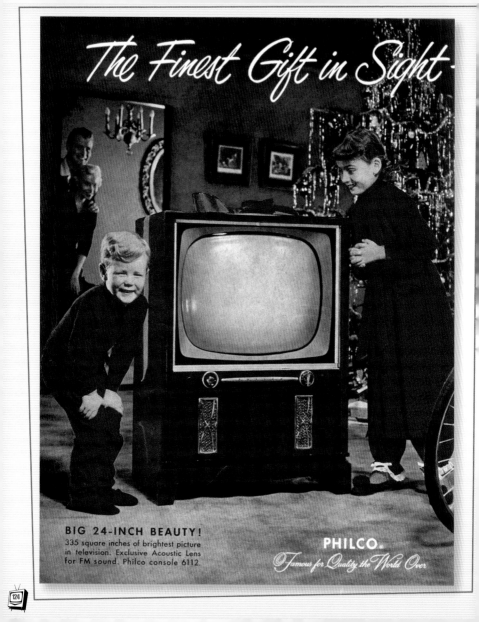

The Finest Gift in Sight

BIG 24-INCH BEAUTY!
335 square inches of brightest picture in television. Exclusive Acoustic Lens for FM sound. Philco console 6112.

PHILCO.
Famous for Quality the World Over

A Charlie Brown Christmas, sponsored by Coca-Cola, helped make 1965 special. In the special, Charlie Brown bemoaned the commercialism of Christmas and discovered its true meaning.

F or Christmas 1963, Motorola asked, "Why Not Give Presents that Give Lasting Enjoyment?" One ad featured three children, clad in red Dr. Denton pj's, gathered around a large cabinet-style TV wrapped up with a red bow.

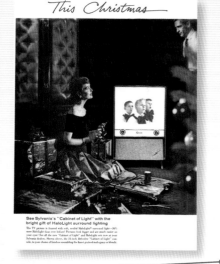

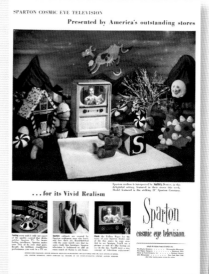

N ew portable sets in the mid-1950s could "go where you go" whether you were indoors, outdoors, or anywhere around the house. General Electric's (GE) "personal" TVs (only thirty-two pounds!) started as low as $99.95. Prices ranged from $129.95 for a 14-inch portable with an ebony finish, to $750 for the 21-inch "Anderson" color console with a luxurious walnut-grained finish.

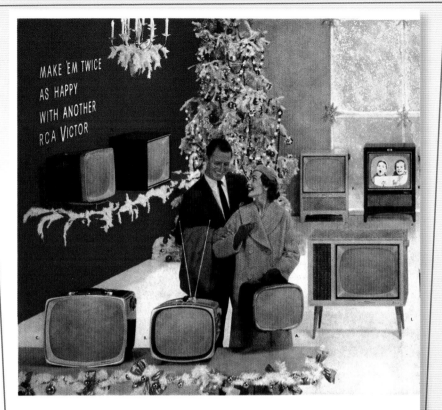

MAKE 'EM TWICE
AS HAPPY
WITH ANOTHER
RCA VICTOR

Look! Portable TV from $129.95 — It's a wonderful Christmas

Easy to see why Santa delivers more RCA Victor TV than any other kind. No other TV offers so many fine features or such a choice of models— 47 of them, completely new inside and out.

New lean, clean and mirror-sharp black-and-white TV. Dramatically slender and clean of line, it fits beautifully where other TV couldn't go at all. Cabinets are up to 9½ inches slimmer! And look at the *variety:* trim table models, TV that rolls, swivels and even fits *in corners.*

Listen to it! That's Balanced Fidelity Sound— the finest! You also get the newest tuning fea-

tures and "One-Touch" on-off control.

New "Flight-Line" Portables. Breezy, easy-going TV to take along, in every popular *size.* Popular prices, too. Your ideal second set.

Most important, every model gives you RCA Victor's new "Mirror-Sharp" picture for the sharpest, clearest contrasts in TV!

New "Living Color" TV, including the superb new Mark Series. The happiest surprise a Santa could put under any tree, the gift of color! It's *performance-proved*—backed by service records from tens of thousands of homes. The colors

come in bright, natural, with realism that's near startling. Tuning is a snap. The picture *holds* sure and steady. And you get great color programs every day *plus* all the black-and-white shows.

Contact your favorite Santa or TV dealer— and ask for RCA Victor TV *soon*—you'll make sure of a wonderful Christmas.

BE SURE TO SEE the Perry Como show on Saturday evenings— and the George Gobel-Eddie Fisher shows on Tuesday evenings. Also "Tic Tac Dough" on Thursday evenings and "The Price Is Right" on Monday evenings. All on NBC-TV.

Before Christmas— Better See

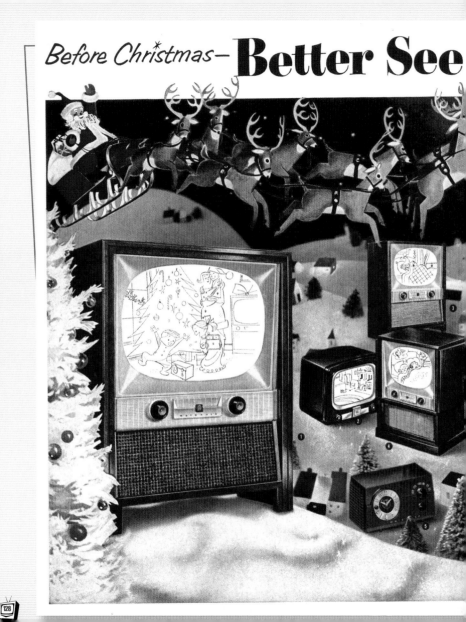

Motorola TV
—and Motorola Radios, Too!

Gift Month! See your Motorola Dealer for the Greatest Gifts in Town!

Bigger screens were just one aspect of TV evolution through the 1950s and 1960s. They also had sleek new designs that allowed sets to fit flush against the wall (thanks to smaller picture tubes), swivel screens, high-fidelity sound, earphone attachments, and "full-room vision" due to wide-angle screens. No doubt, the new features were fun, but they all paled in comparison to the excitement that came from owning your first (affordable) color television in the 1960s.

In 1957 there were so many options available to TV buyers that RCA Victor offered forty-seven models, completely new inside and out.

Philco declared 1947 "the year of the television," and promoted Christmas as a great time to bring the "new world of [TV] entertainment" into your home.

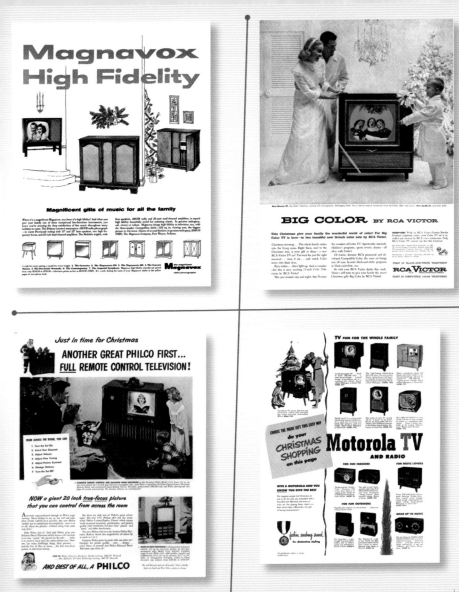

Open before <u>before</u> Christmas!

here's why:

there's so much going on in NBC BIG COLOR TV ...every night!

No matter what day of the week your new Color TV set arrives, tune it in and start enjoying NBC Big Color. There's lots of it . . . *every night!*

Night after night on NBC, you can see great shows like Alcoa-Goodyear Playhouse, the new Walter Winchell Show, Robert Montgomery Presents, Dinah Shore's once-a-month Chevy Show, Kraft Television Theater, The Perry Como Show, Noah's Ark, Bob Hope's Chevy Show, and Lux Video Theater . . . all in Color! And most weekday *afternoons,* NBC Matinee Theater brings you a live, full-hour, Big Color play.

More Big Color news! This Saturday night, the Esther Williams Aqua Spectacular. October 5, Dinah Shore's first full-hour Chevy Show.

October 15, William Wyler's production of Somerset Maugham's gripping drama, "The Letter," on Producers' Showcase. And, on October 28, Mary Martin stars in "Born Yesterday" on the Hallmark Hall of Fame.

That's just October. Between now and Christmas, there'll be a dazzling succession of Big Color shows on NBC. You can see them all in black-and-white, of course. But why wait till Christmas for Color? You could be enjoying so many NBC programs so much more . . . *right now.*

Exciting things are happening
every night on **NBC COLOR TELEVISION**

a service of RCA

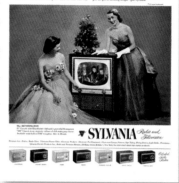
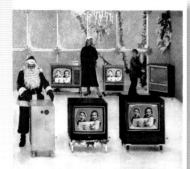
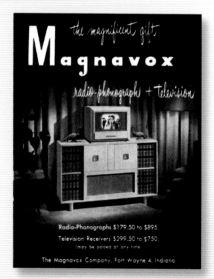
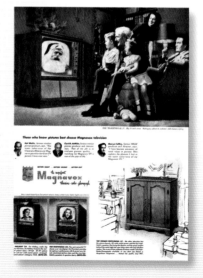

NBC broadcasted the first *Bob Hope Christmas Special* in 1953. The show was filmed during Bob's regular performances entertaining troops stationed overseas.

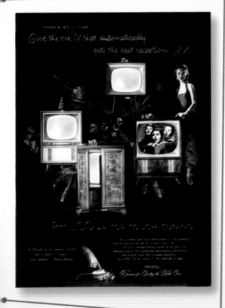

One of the first television specials (then called "spectaculars") was *Peter Pan*, starring Mary Martin, in 1955.

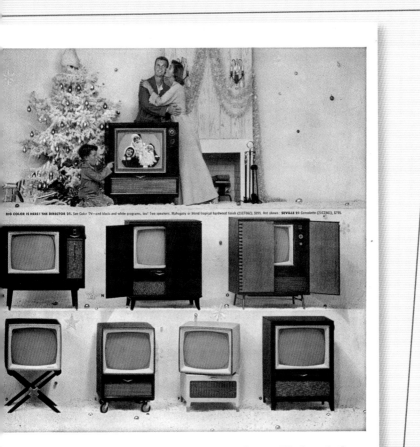

BIG COLOR IS HERE! THE DIRECTOR 21. See Color TV—and black-and-white programs, too! Two speakers. Mahogany or blond tropical hardwood finish (21CT662), $895. Not shown: SEVILLE 21 Consolette (21CT661), $795.

ive RCA Victor than any other Television

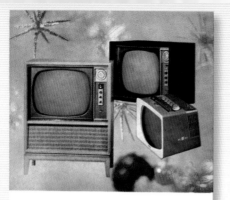

THE GIFT YOU'LL BE LOVED FOR

A THIRD FROM TV BULK

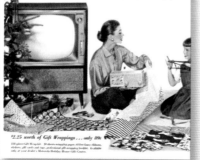

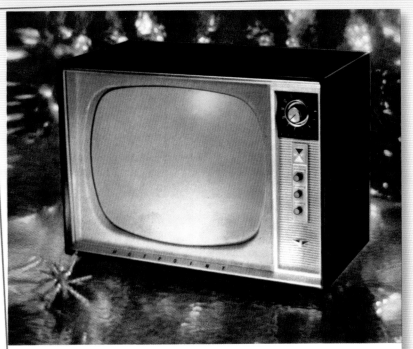

SLEEK NEW HOTPOINT TABLE MODEL in ebony finish is only 15" deep—really fits on a table! Loaded with outstanding new features, yet priced among the lowest. 262 square inches of viewable picture area. Shown: Model 215KW. This, and the Hotpoint Portable (below), were selected as outstanding examples of American design for the eleventh Triennale in Milan, Italy—world's most important international exhibit of industrial design, architecture and home furnishings.

A THIRD FROM TV BULK

LEFT: Old, long-neck 90° picture tube makes TV cabinets huge and bulky, hard to fit into room schemes.

RIGHT: New Hotpoint "Mirrorbeam" 110° picture tube is shorter by far, means up to 35% reduction in cabinet depth of 1958 Hotpoint TV.

EXCITING NEW HOTPOINT FEATURES FOR '58—New MIRACLE MEMORY (left) brings in channels already fine-tuned! Touch Button Power Tuning! Front Speaker Table Models! 3 Hi-Vi SPEAKERS (center) in consoles. "Powertronic Chassis" vastly improves fringe area reception! REMOTE CONTROL (right) at no extra cost on Power Tuning Consoles, optional with Power Tuning Table Models! And these are only a few of the big, important new features in Hotpoint Hi-Vi TV for '58!

SLENDER HOTPOINT CONSOLE has "Miracle Memory," 3 Speakers, Remote Control at no extra cost. Mahogany or Light Oak finish. 262 square inches of viewable picture area.) Shown: Model 215OG.

NEW HOTPOINT PORTABLE (14" over-all diagonal: 108 square inches of viewable picture area). One of 4 new Hotpoint Portables in 2 screen sizes. Less weight, bigger pictures. Shown: Model 145PM.

with Rowan & Martin, Jefferson Airplane, Bobbie Gentry. Special Guest

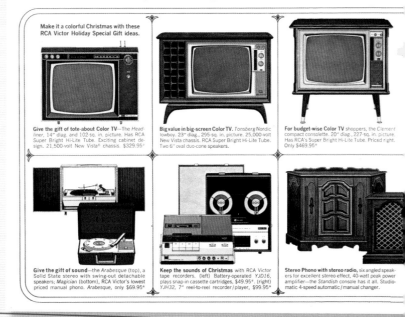

Make it a colorful Christmas with these RCA Victor Holiday Special Gift ideas.

Give the gift of tote-about Color TV—The *Head-liner*, 14" diag. and 102-sq. in. picture. Has RCA Super Bright Hi-Lite Tube. Exciting cabinet design. 21,500-volt New Vista® chassis. $329.95*

Big value in big-screen Color TV. *Tonsberg* Nordic lowboy. 23" diag., 295-sq. in. picture. 25,000-volt New Vista chassis. RCA Super Bright Hi-Lite Tube. Two 6" oval duo-cone speakers.

For budget-wise Color TV shoppers, the *Clement* compact consolette. 20" diag., 227-sq. in. picture. Has RCA's Super Bright Hi-Lite Tube. Priced right. Only $469.95*

Give the gift of sound—the *Arabesque* (top), a Solid State stereo with swing-out detachable speakers; *Magician* (bottom), RCA Victor's lowest priced manual phono. *Arabesque*, only $69.95*

Keep the sounds of Christmas with RCA Victor tape recorders. (left) Battery-operated *YJD16*, plays snap-in cassette cartridges, $49.95*. (right) *YJH32*, 7" reel-to-reel recorder/player, $99.95*

Stereo Phono with stereo radio, six angled speakers for excellent stereo effect, 40-watt peak power amplifier—the *Standish* console has it all. Studio-matic 4-speed automatic/manual changer.

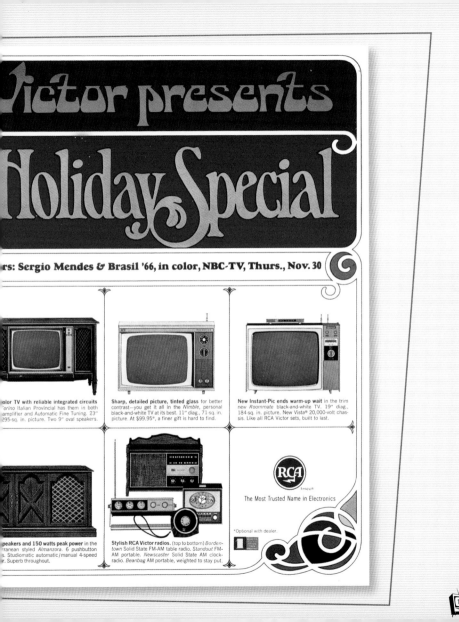

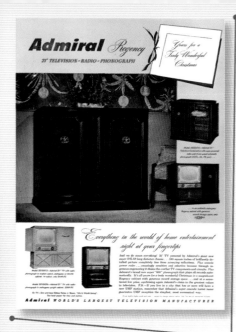

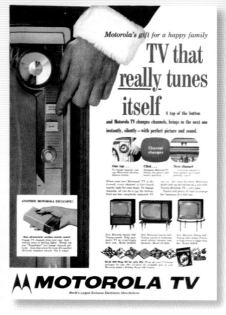

F or Christmas 1957 you could buy a new "Admiral" with a "Son-R" remote control, the "only remote in the world that adjusts volume levels! No wires! No batteries! No stirring from your chair!"

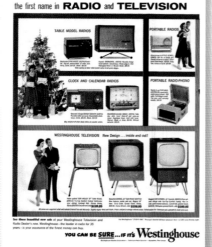

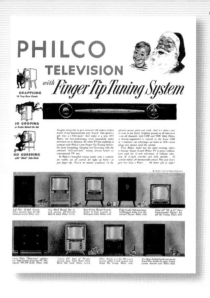

Is it any wonder that all Bobby wanted for Christmas was a new baseball cap and glove? In the 1950s and 1960s favorite sports heroes were almost as likely to show up in TV ads as they were on the playing field. Willie Mays paused for a Coke, Joe Namath had his Ovaltine, Frank Gifford enjoyed Kent Cigarettes, and Mickey Mantle went to bat for Karo Syrup.

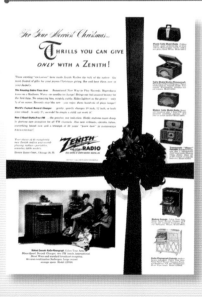

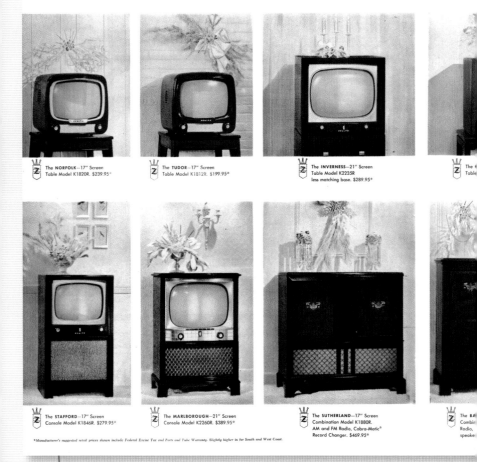

Give your family a Zenith *Qu*

The **NORFOLK**—17" Screen
Table Model K1820R. $239.95*

The **TUDOR**—17" Screen
Table Model K1812R. $199.95*

The **INVERNESS**—21" Screen
Table Model K2235R
less matching base. $289.95*

The **...**
Table...

The **STAFFORD**—17" Screen
Console Model K1846R. $279.95*

The **MARLBOROUGH**—21" Screen
Console Model K2260R. $389.95*

The **SUTHERLAND**—17" Screen
Combination Model K1880R.
AM and FM Radio, Cobra-Matic®
Record Changer. $469.95*

The **BA...**
Combi...
Radio,...
speake...

Manufacturer's suggested retail prices shown include Federal Excise Tax and Parts and Tube Warranty. Slightly higher in far South and West Coast.

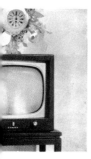

The holidays were bright with Christmas stars when it came to TV programming. In 1967 RCA Victor sponsored Perry Como's *Holiday Special*, with guests like Rowan & Martin, Jefferson Airplane, and Bobby Gentry. Each year brought another entertainer's take on the classics.

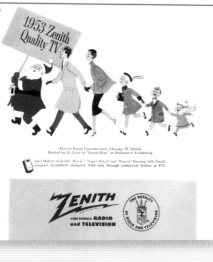

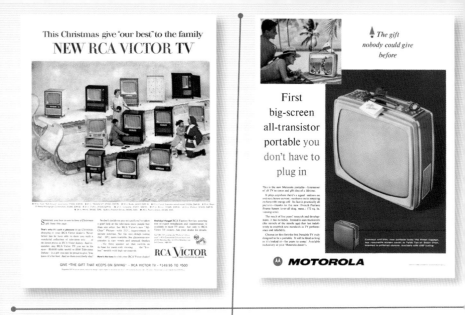

Holiday time was TV time, especially for the kids. The longest-running Christmas special for children is *Rudolph the Red-Nosed Reindeer*, which debuted on CBS in 1964. Burl Ives is the narrator.

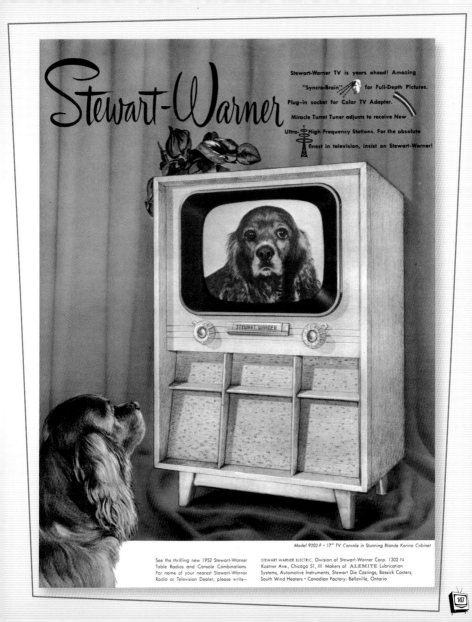

Stewart-Warner

Stewart-Warner TV is years ahead! Amazing "Syncro-Brain" for Full-Depth Pictures. Plug-in socket for Color TV Adapter. Miracle Turret Tuner adjusts to receive New Ultra-High Frequency Stations. For the absolute finest in television, insist on Stewart-Warner!

Model 9202-F • 17" TV Console in Stunning Blonde Korina Cabinet

See the thrilling new 1952 Stewart-Warner Table Radios and Console Combinations. For name of your nearest Stewart-Warner Radio or Television Dealer, please write—

STEWART-WARNER ELECTRIC, Division of Stewart-Warner Corp. 1302 N. Kostner Ave., Chicago 51, Ill. Makers of ALEMITE Lubrication Systems, Automotive Instruments, Stewart Die Castings, Bassick Casters, South Wind Heaters • Canadian Factory: Belleville, Ontario

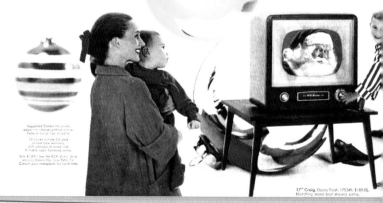

3-speed players

"Victrola" 3-speed—featuring the "Slip-On" spindle for "45". Plays all your records easier, *automatically!* Up to five hours of music at the touch of a button!

"Victrola" 45 radio-phonograph, AM radio, "45" automatic changer, 9V510, $69.95

"Victrola" 3-speed attachment. Can play any record through radio or TV set. 2TS1, $49.95

"Victrola" 3-speed automatic phonograph. Up to five hours of music. 2ES31, $69.95

"Victrola" 3-speed portable phonograph. AC operation. Smart luggage styling. 2ES38, $99.95

"Victrola" 3-speed radio-phonograph. Mahogany, walnut finish limed oak extra!. 2U57, $129.95

"45" automatic table phonograph, extra sensitive speaker. 45EY4, $49.95

21" Chadwick. Full door Empire console in rich mahogany or warm walnut finish. 21T373, $439.50

21" Deluxe Talmadge. Extra tubed Mahogany finish limed oak extra!. 21D368, $395.00

21" Deluxe Newport. Swivel base. Walnut or limed oak finish. 21D378, $495.00

21" Deluxe Beaumont. Rich mahogany, maple or mahogany-cherry finish. 21D380, $525.00

27" Deluxe Copeland. Giant screen! Has exclusive Definition Control. Mahogany, walnut finish. 27D383, $700.00

"Hawell. Full-length Mahogany, mahogany or maple finish. 21T373, $439.50

High Fidelity "Victrola" phonographs

"Towner" Powerful AM/FM radio. 2XF931, $67.50

"Personal" table radio. 2X51, $29.95

"Personal" clock-radio. Clock face! Four colors. 2C511 Series, $39.95

"Personal" portable, shown below. 6" high 2BX00, $29.95

Now a thrilling new achievement in sound reproduction—priced for everyone to enjoy! Brings you the "hidden" music on your records you've never heard before.

High-Fidelity "Victrola" table phonograph. Mahogany finish limed oak extra!. 3HES5, $139.95

High-Fidelity "Victrola" console phonograph. Mahogany, walnut finish limed oak extra!. 3HS6, $275.00

"to-World" table radio, AM plus wide short wave. 71, $139.95

eeps on Giving" for <u>everyone</u>!

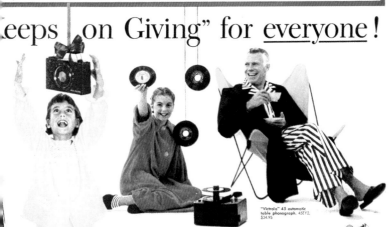

"Victrola" 45 automatic table phonograph, 45EY2, $34.95

RCA VICTOR WORLD LEADER IN RADIO...FIRST IN RECORDED MUSIC...FIRST IN TELEVISION
Tmks. ® Division of Radio Corporation of America

149

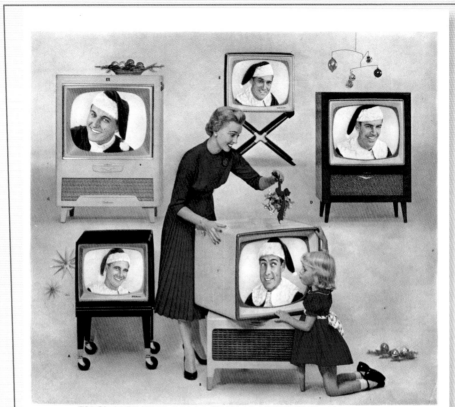

(A) Thriflon 17. Ebony finish (17T6022). $149.95. Matching stand, optional, extra. (B) Pickwick 21. Limed oak grained finish (21T6257). $259.95. (C) Everest 24 Deluxe. In mahogany grained finish (24D655). $349.95. Shown in limed oak grained finish, $389.95. (D) Brady 21 in mahogany grained finish (21S632). $249.95. (E) Headliner 21. Ebony finish (21T6083). $199.95. Matching stand optional, extra.

Every Christmas more Santas give RCA Victor than any other television!

Now at your RCA Victor dealer's—a wide, wonderful selection of new TV styles. Priced as low as $149.95

If your particular Santa keeps smiling to himself these days, maybe it's because he's planning to surprise the whole family with new RCA Victor TV for Christmas.

Could be you're getting the *Thriflon 17*, best buy in 17-inch TV. Only $149.95—with fine performance and "Hidden Panel" tuning. Or maybe your Santa has his eye on the *Headliner 21*, with Oversize 21-inch picture tube and "4-Plus" picture quality . . . for improved brightness, contrast, steadiness.

If it's the new *Brady 21*, your Santa knows value. It's the lowest priced 21-inch console in RCA Victor history! Or it could be the two-speaker *Pickwick 21*. Here's TV that turns—so you don't have to. If this is an *extra-special* Christmas, you may even be getting Television Deluxe—like the handsome, bigger-than-life *Everest 24 Deluxe*.

But if your Santa hasn't gotten into the Christmas spirit yet—better drop a hint and direct him to your RCA Victor dealer's.

RCA Factory Service, assuring expert installation and maintenance, is available in most areas—but only to RCA Victor TV owners. Optional, extra.

See Milton Berle, Martha Raye alternately on NBC-TV, 2 out of every 3 Tuesdays. And don't miss NBC-TV's spectacular "Producers' Showcase" in RCA Compatible Color or black-and-white, Dec. 12.

Manufacturer's nationally advertised VHF list prices shown, subject to change. Slightly higher in Far West and South. UHF optional at RCA Victor's lowest price ever—only $20 extra.

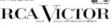

RCA VICTOR
RADIO CORPORATION OF AMERICA

Give RCA Victor TV—"The Gift That Keeps On Giving."

The best TV specials, according to one top TV authority, are *A Charlie Brown Christmas* (1965), *Elvis Presley's '68 Comeback Special*, *How the Grinch Stole Christmas!* (1966), *The Undersea World of Jacques Cousteau* (1968), *National Geographic* specials, *Free to Be . . . You and Me* (1972), *Jackie Kennedy's White House Tour* (1962), *Rankin/Bass Christmas* specials, *A Very Brady Christmas* (1988), and Bob Hope Christmas shows.

Charlie Brown was around for other holidays, too: *A Charlie Brown Thanksgiving* (1973); *It's the Great Pumpkin, Charlie Brown* (1966); *Be My Valentine, Charlie Brown* (1975); *Happy New Year, Charlie Brown* (1986); and *It's the Easter Beagle, Charlie Brown* (1974).

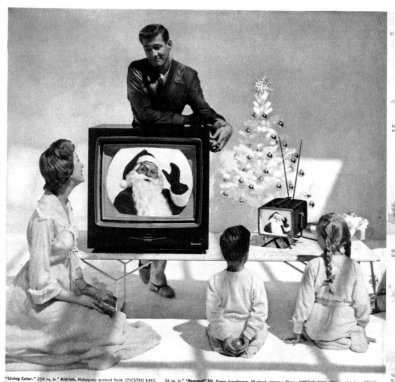

"**Living Color.**" 254 sq. in." **Aldrich.** Mahogany grained finish. (21CS781) $495. 36 sq. in.° "**Personal**" **TV.** Power transformer, tilt stand, antenna. Ebony. (8PT703) $125. Other models from $99.95.

Shop Here for RCA Victor "Living

Play Santa with America's First Choice In Television! On these two pages—11 happy gift ideas for the whole family. For example...

Christmas in Color! Surprise the family with a spectacular gift—RCA Victor Big Color TV. Now as low as $495—lowest price in RCA Victor history.
See natural "Living Color"—from the delicate tint of a tea rose to the stunning tones of a Spectacular. All the colors of life!
This is BIG Color—with a big-as-life screen! Actually 254 square inches of viewable picture, on a 21-inch picture tube (overall diameter).
It's like having 2 sets in 1! For the price once paid for black-and-white alone, you see all Color shows in "Living Color" *plus* all regular programs

in crisp, clear black-and-white. It's RCA Victor *Compatible* Color TV.
So easy to tune, a child can do it. Turn two knobs and the screen blossoms out in Color.
Choose from 10 models—masterpieces of modern or traditional styling. From a table model to luxurious consoles—it's Color TV's first complete line!
Or give a TV Original—new shapes, new sizes, new styles, new convenience in black-and-white TV.
New "*Personal*" TV starts at $99.95—smartest, smallest TV ever! And it's a *full-fledged* TV set with sturdy ease and regular power transformer.

"PERSONAL"
CA Victor TV, 36 sq. in.* screen, handle, power
tenna connection. Ebony. (8PT703) $99.95.

TABLE TV
Big-screen TV—budget price. "High-Sharp-and-Easy" tuning.
261 sq. in.* Dixon. Ebony finish. (21T715) $219.95.

SWIVEL
Built-in phono-jack for record player! 261 sq. in.* Enfield.
Mahogany grained finish. (21T73B) $299.95.

ROLLAROUND
picture. "Window Knob" indicator. 261 sq. in.* Ardmore Deluxe.
ned finish. (21D721) $269.95.

LOWBOY
Fine furniture—2 speakers, 261 sq. in.* Raeburn. Smart limed
oak grained finish. (21T741) $339.95.

LUXURY CONSOLE
3 speakers! Big, big screen. 329 sq. in.* Brantley Deluxe.
Mahogany figured finish. (24D770) $475.

LIVING COLOR"
picture. "Window Knob" indicator. 254 sq.
imed oak grained finish. (21CT715) $595.

"LIVING COLOR"
Handsome new lowboy. Easy "Color-Quick" tuning. 254 sq.
in.* Dartmouth. Mahogany grained finish. (21C1786) $650.

"LIVING COLOR"
3-speaker Panoramic Sound. Provincial styling. Wingate
Deluxe. Genuine maple veneers and solids. (21CD799) $850.

lor"—and TV Originals From $99⁹⁵

Panoramic Sound in most Deluxe
nazing "you are there" realism—finest
 with TV's finest picture!

arp-and-Easy" tuning. Tune standing
Agic Brain" remote TV control available
dels (optional, extra).

you want in TV—for yourself or for a
Victor has it. And remember: ask your
ut easy budget terms on RCA Victor
hite or Big Color TV.

Manufacturer's nationally advertised VHF list prices shown. Prices
and specifications subject to change. UHF optional, extra (not
available on "Personal"). Some sets slightly higher far West and
South. Most models available in Canada.

At your service: RCA Victor Factory Service Contracts available
in most areas but only to RCA Victor TV owners. Special low-cost

1-year contract on "Personal" or portable—only $14.95. Special
90-day Big Color TV contract only $39.95.

SEE TOP SHOWS IN COLOR and black-and-white over
NBC-TV: "The Perry Como Show," Sat., Dec. 15; "Saturday
Color Carnival," Dec. 22. Co-sponsored by RCA Victor.

| lowable picture area | 36 | 108 | 254 | 261 | 329 |
| all diagonal or diameter | 8" | 14" | 21" | 21" | 24" |

Social & Hospitable

In the early days of TV, when not every family was fortunate enough to own a set, people gathered for glimpses of this amazing machine wherever they could find them. Stores selling TVs kept some turned on in the front windows, and crowds gathered around to enjoy whatever program happened to be on. If your family was lucky enough to have a set, it was your social responsibility to share your good fortune with your friends and neighbors.

Today it would seem inhospitable for the host or hostess to turn on the TV and watch a show while entertaining guests, but in those early days it was rude not to offer them a glimpse of your precious TV. As a matter of fact, gatherings for the purpose of watching TV were commonplace events. This was true of big events such as sports spectaculars and holiday specials, but people also got together to watch weekly favorites, such as the *Texaco Star Theater*. Once TV took root the fabric of Americans' social lives began to change. Diners either went to restaurants early or skipped eating out altogether on nights when the most popular shows aired.

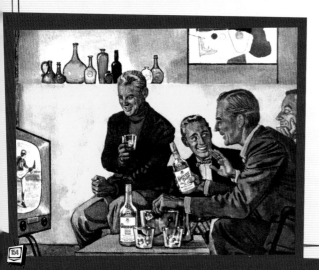

Advertisers noticed that the products shown on TV quickly outsold those not featured there. Both libraries and booksellers suffered as fewer people chose to spend their spare time reading. There are even studies that showed that water pressure decreased in cities all over the country during commercials and at the end of TV favorites like *I Love Lucy* and *The Honeymooners*, as viewers

waited for opportune times to make trips to the bathroom.

TV created a form of entertainment that gave viewers a much greater intimacy with performers than ever before. Early TV shows featured many close-ups, so people were actually face-to-face with the characters they came to know. Plus, these characters came into viewers' homes with them. People could gather with friends as they invited stars in, but they could also be entertained in their slippers and bathrobes when they chose more privacy. Somehow it seemed that TV personalities were more a part of viewers' own social groups than any movie star or stage performer had ever been before.

With people gathering together to view TV, other features of entertaining had to adapt. How much more fun it was to watch TV and snack! The popular chip-and-dip dishes and recipes of the 1950s and 1960s were perfect for TV-viewing and sharing. Lipton's Onion Soup mix and sour cream were staples in many kitchens of TV-viewing families. And Jiffy Pop made it quick and easy to offer entertainment complete with popcorn. TV trays became popular living room accessories so that serving these treats was convenient and easy. They were also very useful for supporting TV dinners, which soared in popularity throughout the 1950s. Every living room became a place to gather with family and friends around the TV. Over the years we came together in good times and bad. Whether we were there to enjoy the Miss America Pageant, marvel at the first space launches, or grieve over the loss of President Kennedy, we were together and sharing our view of the world through our own magical television window.

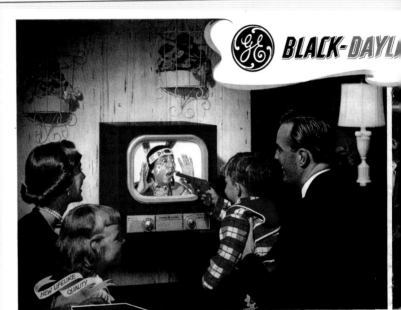

GE BLACK-DAYL[...]

NEW LIFELIKE QUALITY

Model 14T2, *above. 14" rectangular tube. Genuine mahogany veneers. Also in blond.*

MODEL 16C113

MODEL 14C102

MODEL 16T3

GENERAL ELECTRIC PROUDLY PRESENTS THE... *Newest,*

● New all through . . . combining big-as-life pictures . . . furniture of surpassing loveliness . . . the "shows-all" G-E rectangular black tube . . . plus many other betterments developed or pioneered by General Electric . . . the wonderful advance 1951 series G-E Black-Daylite Television is now ready for your most critical inspection. Designed in genuine mahogany veneers or choicest blond woods, these superbly styled receivers bring you the lasting pride and thrilling enjoyment of owning the finest. So surprisingly inexpensive that anyone who can afford television at all can afford a General Electric

● **16C113.** Exquisite, genuine mahogany veneers. 16" rectangular tube.
● **14C102.** Handsome mahogany veneered console. 14" rectangular tube. Also in blond.
● **16T3.** Compact mahogany veneered cabinet. 16" rectangular tube. Also in blond.

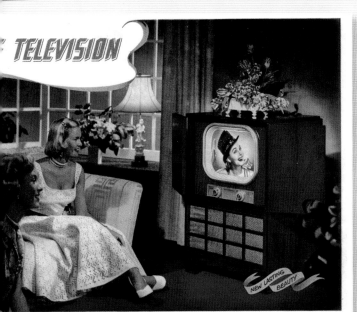

TELEVISION

NEW LASTING BEAUTY

116, above. 16" rectangular tube. Finely figured doors and a master-crafted cabinet in genuine mahogany veneers.

e-Size Beauties

...re so lifelike, so realistic, you feel you're right on the scene.
...ngular black tube shows all, misses nothing. You see every-
... TV camera sees. Deeper, blacker, truer-to-life than ordinary
...tune the picture—the sound is right everytime! And what
...ear, natural, alive! Powerful built-in antenna—standard in all
...here's the answer to television you can live with for years . . .
...rious, backed by a name you can depend on . . . at popular
...r the finest in G-E history, see these new receivers at your
...oday. *General Electric Co., Electronics Park, Syracuse, N. Y.*

NEW LIFE-SIZE PICTURE

You'll be happier longer with G.E.'s big-as-life, true-to-life picture.

...un put your confidence in

GENERAL ⊕ ELECTRIC

fresh, clean taste!

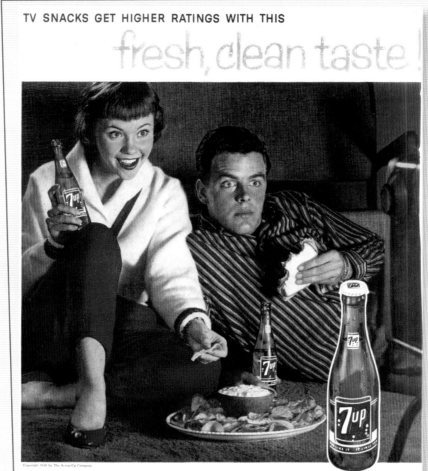

Copyright 1956 by The Seven-Up Company

Nothing does it like Seven-Up

If you could peek into TV rooms across the nation, you'd find potato chips, popcorn, sandwiches— and 7-Up! Happy munchers everywhere have discovered that the fresh, clean taste of 7-Up makes whatever you eat taste better! Actually, 7-Up—sipped between bites—sharpens your taste buds so all the good flavors come through. *You* try it, too! YOU LIKE IT...IT LIKES YOU

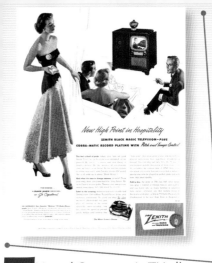

The biggest TV hits of the late 1950s and 1960s included the usual sitcoms, Westerns, and detective shows, but the fantasy/sci-fi genre was also huge. *The Twilight Zone* (1959–64) topped this list, followed by *My Favorite Martian* (1963–66), *The Outer Limits* (1963–65), *Bewitched* (1964–72), and *Star Trek* (1966–69).

TV and Swanson's TV dinners proved to be a tasty combination. By 1954 — only one year after their debut — Swanson's had sold more than 25 million TV dinners. The first TV dinner included all the fixings for a good Thanksgiving meal — turkey, gravy, cornbread stuffing, peas, sweet potatoes — and cost a mere 98 cents. In 1960 Swanson's added desserts to its TV dinners line, but its turkey dinner was still tops.

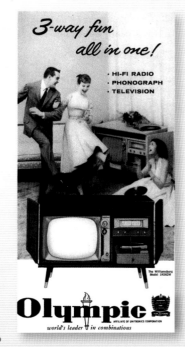

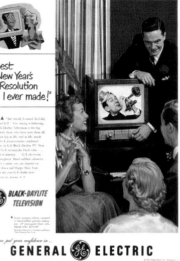

In 1949 the typical family watched TV for 4.4 hours a day. By the end of the 1960s, TV viewing had grown steadily to 5.5 hours per day.

It's a wonder Joan Nash, the mom in *Please Don't Eat the Daisies* (1965–67), didn't have to return her Mom Badge. She was a misfit in the world of 1965 television: she hated housework and cooking, and she didn't go for gossiping with the neighbors.

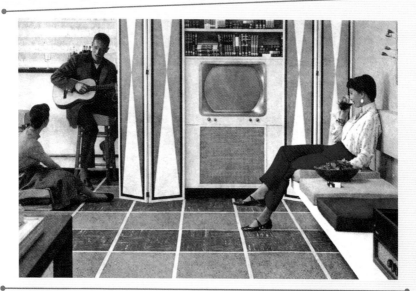

Rowan and Martin's Laugh-In (1968–73) was one of TV's biggest hits of the 1960s, but it also inspired TV's most notorius flop. *Turn-On*, a sorry *Laugh-In* clone, was cancelled after only one show in 1969. It had skits like *Laugh-In* did and even had the same producers, but the knock-off lacked the original show's imagination. After all, there could be only one *Laugh-In*!

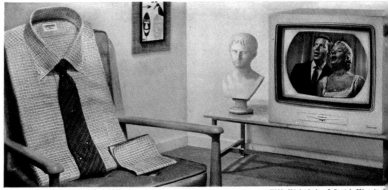

Arrow Shirts, $5.00, All-silk Ties, $2.50, Handkerchief, $.75

Aldrich. 21-inch tube (overall diameter)—254 sq. in. of viewable picture. Limed oak grained finish. (21C5781.) $495.

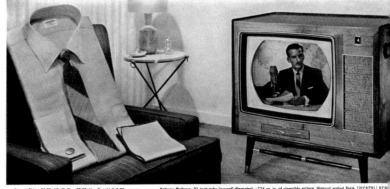

Arrow Shirts, $5.00, All-silk Ties, $2.50, Handkerchief, $.75

Asbury Deluxe. 21-inch tube (overall diameter)—254 sq. in. of viewable picture. Natural walnut finish. (21CD791.) $75¢

Compatible Colors to <u>wear</u> by ARROW...

You won't have to decide what colors to wear together
with this exciting new Compatible Color group by Arrow. These shirts, ties, and handkerchiefs were color-styled to go with each other . . . and to harmonize perfectly with almost any suit you own. And all are Arrows, through and through. Shirts are carefully tailored to fit you

exactly, "Sanforized"-labeled, to stay that way. And . . . you can't buy a longer-wearing shirt. *Cluett, Peabody & Co., Inc.*

ARROW ⟶ first in fashion

COMPATIBLE COLOR

Arliss Deluxe. 21-inch tube (overall diameter)—254 sq. in. of viewable picture. Genuine mahogany veneers and solids. (21CD797.) $850.

Westcott. 21-inch tube (overall diameter)—254 sq. in. of viewable picture. Mahogany grained finish. (21CT785.) $595.

Compatible Colors to <u>see</u> by RCA VICTOR

Don't wait! Starting this Fall you can see TV shows in *"Living Color"* every night of the week—see regular black-and-white programs, too—on the same set! It's new RCA Victor Compatible Color TV—now as low as $495 . . . a price once paid for black-and-white TV alone. Ask your RCA Victor dealer for a demonstration and about easy credit terms.

SEE TOP SHOWS IN COLOR and black-and-white over NBC-TV. "The Perry Como Show," Sat., Oct. 20; "Saturday Color Carnival," Oct. 27. Co-sponsored by RCA Victor. Manufacturer's nationally advertised VHF list prices shown. UHF opt., ea. Some sets slightly higher for West, South, Canada. Specifications and prices subject to change.

Symbol of RCA Victor Compatible Color TV

RCA VICTOR
RADIO CORPORATION OF AMERICA

RCA PIONEERED AND DEVELOPED COMPATIBLE COLOR TELEVISION

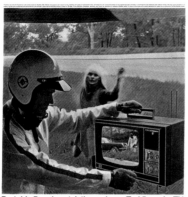

Portable People catch the replay on Toshiba color TV

Toshiba
THE INTERNATIONAL ONE

For Christmas, give a
new concept in TV pleasure

HOTPOINT Hi-Vi TV

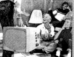

Hotpoint HI-VI TV

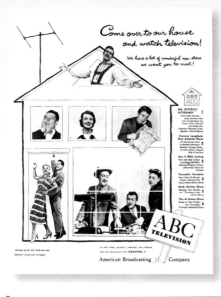

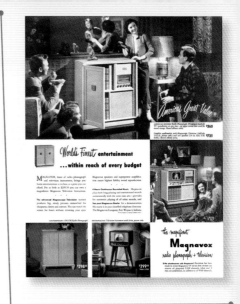

*T*he *Mickey Mouse Club*, which debuted in 1955, counted many more kids than rodents as members. The show was on every weekday, and each day had its own theme: Monday was "Fun with Music Day," Tuesday "Guest Star Day," Wednesday "Anything Can Happen Day," Thursday "Circus Day," and on Friday kids looked forward to "Talent Round-Up Day."

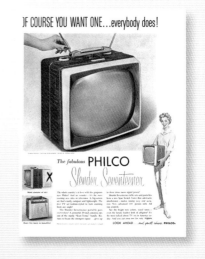

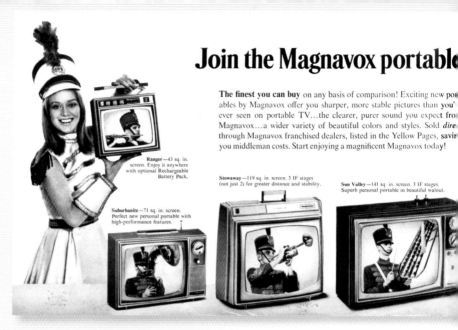

Join the Magnavox portable

The finest you can buy on any basis of comparison! Exciting new portables by Magnavox offer you sharper, more stable pictures than you'ever seen on portable TV...the clearer, purer sound you expect from Magnavox...a wider variety of beautiful colors and styles. Sold *directly* through Magnavox franchised dealers, listed in the Yellow Pages, saving you middleman costs. Start enjoying a magnificent Magnavox today!

Ranger—43 sq. in. screen. Enjoy it anywhere with optional Rechargeable Battery Pack.

Suburbanite—71 sq. in. screen. Perfect new personal portable with high-performance features.

Stowaway—119 sq. in. screen. 3 IF stages (not just 2) for greater distance and stability.

Sun Valley—141 sq. in. screen. 3 IF stages. Superb personal portable in beautiful walnut.

TV parade...best buys, great gifts – from $89.90

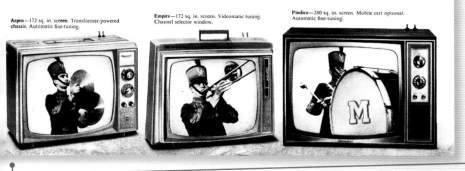
Arnold Zenker replaced Walter Cronkite on the *CBS Evening News* for a time and almost cost the venerable newscaster his job. During a TV actors' strike in 1967 Cronkite joined the actors in their cause. CBS scrambled to fill the anchor's chair. After auditioning the network brass, programmer Zenker got the job because he had handled himself well during a local broadcast earlier that day. Zenker was a smash hit. Such a hit, in fact, that when Cronkite returned three weeks later, he began his broadcast with, "Good evening. This is Walter Cronkite sitting in for Arnold Zenker."

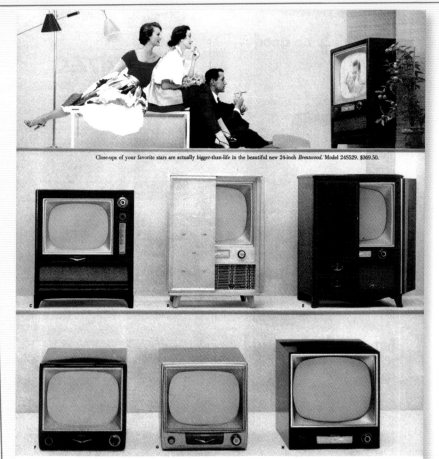

The Flintstones (1960–66) was never intended to be a kiddie show. In fact, Winston Cigarettes was one of its first sponsors. In one Winston ad, Fred and Barney are shown puffing away while lounging in the backyard. The show gave up hawking smokes around the time Pebbles was born.

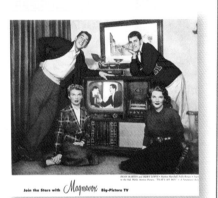

Join the Stars with *Magnavox* Big-Picture TV

The first Emmy Awards ceremony was held in 1949 and hosted by the Los Angeles Athletic Club. Shirley Dinsdale and her puppet Judy Splinters were among the winners. The category: Outstanding Personality.

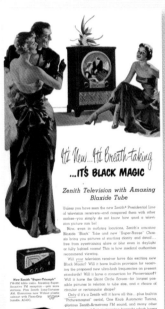

It's New...It's Breath-taking
...IT'S BLACK MAGIC

Zenith Television with Amazing Blaxide Tube

If you remember the show *My Favorite Martian* (1963–66), you undoubtedly were amazed by Uncle Martin's ability to levitate objects just by pointing at them. (Admit it; you tried this yourself, right?) But did you remember that Uncle Martin could do other cool things, such as speak with dogs?

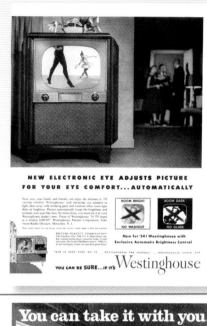

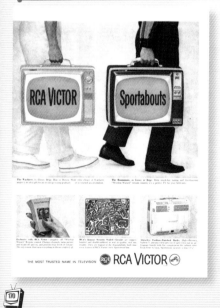

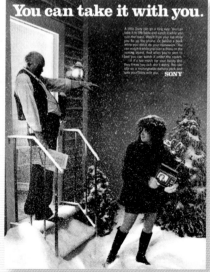

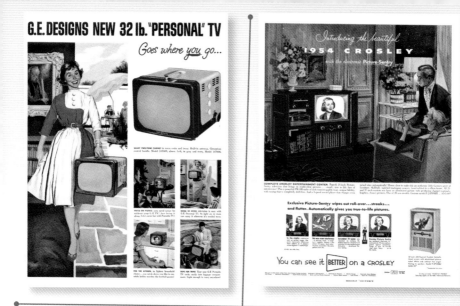

G.E. DESIGNS NEW 32 lb. "PERSONAL" TV

Goes where you go...

Let Magnavox High Fidelity fill your home
with the glow of beautiful music

Magnavox

high fidelity television · radio-phonographs
Precision electronics for industry and our Government

Thanks in part to cornball comedies such as *The Beverly Hillbillies* (1962–71), *The Real McCoys* (1957–63), and *The Andy Griffith Show* (1960–68), CBS had 18 of the top 20 nighttime shows for a time in 1962.

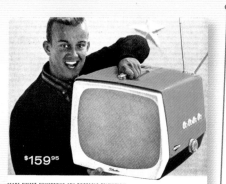

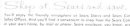

SEARS FINEST SILVERTONE 17" PORTABLE TELEVISION
(17" Overall Diagonal, 155 Sq. In. Viewing Area)
Slim, tapered styling! Here's the big-screen portable that's fully enclosed in a strong, safe Fiberglas® cabinet... weighs only 30 pounds. With its powerful tuner, aluminized screen, and long-range, self-contained, telescoping antenna you get a sharp, clear picture. Wide angle, tinted safety glass for easy viewing. Sunshine Yellow, Aquamarine, or Malibu Coral, $159.95.*(Prices may vary in some areas... All-Channel models at additional cost.)
After 17" television prices start at $109.95

Shop at Sears and save.

You'll enjoy the friendly atmosphere at Sears Stores and Sears Catalog Sales Offices. And you'll find it convenient to shop from the Sears Catalog, in your own home, by mail or phone. Sears employes, you know, are the largest owners of the Sears business. They'll do their best to serve you well.
Sears, Roebuck and Co.—In Canada or Simpsons-Sears Ltd.

SATISFACTION GUARANTEED OR YOUR MONEY BACK

Combat (1962–67) was perhaps the best of the many World War II–based shows from the 1960s. Maybe it was the actual battle footage that was interspersed into each show that made it seem so realistic.

Gomer *Pyle, U.S.M.C.* was spun off from The Andy Griffith Show, but did you know that in the first episode Andy accompanied Gomer from Mayberry to his new home at the marine base?

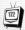

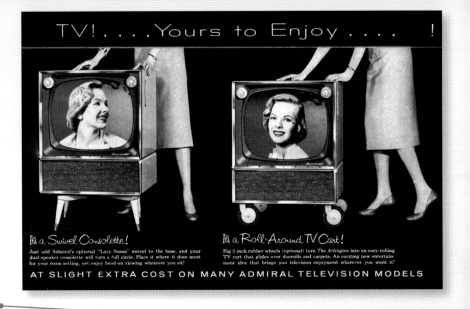

In 1955 housewives longing to escape the sameness of their lives made *Queen for a Day* (1955–64) the number-one daytime show. Contestants would regale the studio audience with sob stories about how lacking their lives were. Usually in tears, they'd wail, "If only I could have a [new refrigerator, new stove, etc.], I'd be happy." The winner — as measured by an applause meter — would be crowned Queen for a Day and adorned with a red velvet robe. Models would then present her with a procession of advertiser-donated gifts.

Conclusion

Now you've enjoyed a nostalgic journey through the early days of TV. You saw its astonishing arrival on the American scene and the frenzy that arrival caused as Americans rushed to include TVs as vital centers of the home. You saw those TVs grow better, fancier, less expensive, and more ubiquitous. You saw them offer something for everyone from toddlers to grandparents. And you saw them come to help families celebrate holidays, special occasions, and social gatherings. They changed the way Americans eat, the way they gather their news, and ultimately the way they think about themselves.

It's so easy to see why TV came into American lives in a burst of wonder, took center stage, and never let go of that spot. What seemed like a frivolous, but much-coveted, luxury in those early days is now an integral part of American life. But its evolution into everyday life hasn't diminished the fascination it holds for its viewers.

The form TV shows now take would be unrecognizable to early viewers. They could never have foreseen reality programming, shocking talk shows, or cable TV's no-holds-barred content. But those early viewers would certainly be able to understand why modern people came to depend so wholly on this wondrous electronic box. Whereas their love affair with TV began with a mere fifteen minutes of daily news coverage, today's viewer can enjoy twenty-four-hour news coverage from every corner of the globe.

The future of the medium is still promising and fascinating. With the integration of the Internet, satellite, and computer services with TVs, it won't

be long before Americans can use ever-improving TV technology for work, research, and education as well as for entertainment. Today's home theaters rival the sound and picture quality of early movie theaters and provide all the same enjoyment right in our homes.

Arguments abound about the benefits and harm television brings to the American family. Arguments aside, no other invention has ever offered greater potential to entertain, educate, inform, and connect people across the country and around the world. No wonder the magic of TV still lives on!